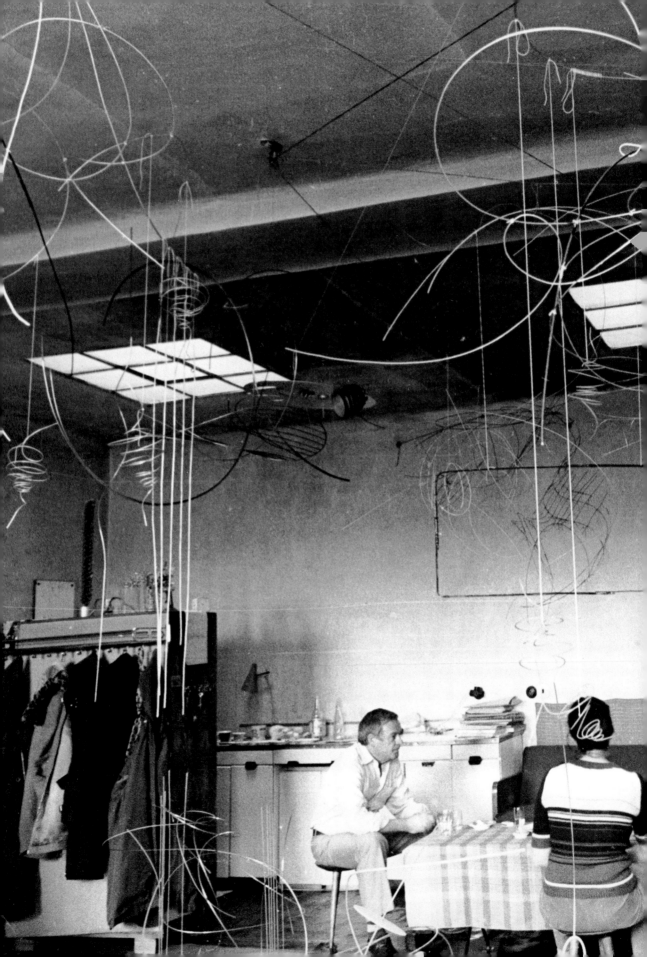

BEYOND
PRECONCEPTIONS:
THE
SIXTIES
EXPERIMENT

ARTISTS

JOSEPH BEUYS

MARCEL BROODTHAERS

LYGIA CLARK

HANNE DARBOVEN

BETTY GOODWIN

VICTOR GRIPPO

EVA HESSE

ILYA KABAKOV

ON KAWARA

JIŘÍ KOLÁŘ

EDWARD KRASIŃSKI

JOHN LATHAM

SOL LEWITT

ANNA MARIA MAIOLINO

KAREL MALICH

MANGELOS

PIERO MANZONI

CILDO MEIRELES

BRUCE NAUMAN

HÉLIO OITICICA

LAWRENCE WEINER

BEYOND PRECONCEPTIONS: THE SIXTIES EXPERIMENT

CURATED BY
MILENA
KALINOVSKA

ESSAYS BY
PAULO
HERKENHOFF

MILENA
KALINOVSKA

MICHAEL
NEWMAN

LAWRENCE R.
RINDER

JIŘÍ ŠEVČÍK
AND
JANA ŠEVČÍKOVÁ

INDEPENDENT
CURATORS
INTERNATIONAL
NEW YORK

Published to accompany the traveling exhibition
Beyond Preconceptions: The Sixties Experiment,
organized and circulated by Independent Curators
International (ICI), New York. Guest curator
for the exhibition, Milena Kalinovska.

For Carol, Jan and Shellburne, who made it possible.
MK

EXHIBITION FUNDERS
The Rockefeller Foundation
The Penny McCall Foundation
The Foundation-To-Life, Inc.
The Trust for Mutual Understanding
Gerrit L. and Suydam R. Lansing
The ICI International Associates

25
ICI's 25th Anniversary
1975–2000

© 2000 Independent Curators International (ICI)
799 Broadway, Suite 205
New York, NY 10003
Tel: 212-254-8200 Fax: 212-477-4781
www.ici-exhibitions.org

Library of Congress Catalog Number:
00 132504
ISBN: 0-91636-58-1

Project Editor: Stephen Robert Frankel
Additional Editors: Lisa Cohen (Michael Newman essay)
David Frankel (Paulo Herkenhoff essay)
Laura Morris (Lawrence Rinder essay)
Translators: Izabel Murat Burbridge (Paulo Herkenhoff essay)
April Retter (Jiří Ševčík and Jana Ševčíková essay)

Designer: 2 x 4, New York
Printer: Cantz, Germany

Cover: Betty Goodwin, *Feather Nest,* 1972
Front Endpaper, page 1: Karel Malich, detail of work, 1970s
and view of Karel Malich's studio (with the artist on the left), Prague, 1970s
Back Endpaper, page 136: Cildo Meireles, *Meshes of Freedom,* 1976 (details)

EXHIBITION ITINERARY*
Veletržní Palác, Collection of Modern
and Contemporary Art, National Gallery in
Prague, Czech Republic
November 2, 2000–January 14, 2001

Centro Recoleta
Buenos Aires, Argentina
April 2001

Museum of Brazilian Art–
Fundaçao Armando Alvarez Penteado
São Paulo, Brazil
August 2001

Paço Imperial
Rio de Janeiro, Brazil
September 2001

University of California,
Berkeley Art Museum
Berkeley, California
October 31, 2001–January 13, 2002

**As of September 2000*

The Latin American tour of
Beyond Preconceptions: The Sixties Experiment has
been made possible through Instituto Arte Viva,
Rio de Janeiro

arteviva

CONTENTS

FOREWORD
AND
ACKNOWLEDGMENTS

Beyond Preconceptions: The Sixties Experiment has been an extraordinary project for ICI, and a particularly gratifying one to present during our twenty-fifth anniversary year. In developing and organizing this exhibition, Milena Kalinovska, a creative and independent-minded curator known for presenting outstanding work from beyond the mainstream, has collaborated with ICI and five distinguished authors who have wide-ranging curatorial experience and a great depth of art-historical knowledge. Together, we have developed an exhibition and catalogue that explore a selection of historically important and, in many cases, rarely seen works created by distinguished and influential artists from three continents during the decade of the 1960s and the larger period surrounding it, a time of dramatic political and cultural change. And while many works by the better-known North American and European practitioners from this period have been regularly studied and exhibited, political and cultural divides have until just recently kept works by some of the most important artists from Eastern Europe and South America from receiving the attention they deserve. By bringing together some of the best and the most thought-provoking examples from all of these regions, *Beyond Preconceptions* reveals a wide range of shared sensibilities and methods of art making, visual parallels and close conceptual relationships, and a fresh view of one of the most significant moments in the history of twentieth century art, as well as one of enduring interest, especially to artists working today. That the exhibition will be seen by viewers on three continents is a further tribute to the efforts of everyone involved in this project.

This traveling exhibition and catalogue have been made possible through the encouragement, dedication, and generosity of a great many people. First and foremost, I extend our warmest thanks and appreciation to guest curator Milena Kalinovska. This was ICI's second opportunity to work with her, and once again ICI benefited from her collaborative approach, intelligence, dedication, and keen understanding of her subject.

On behalf of both Milena Kalinovska and ICI, I want to express our warmest thanks to the catalogue authors: Paulo Herkenhoff; Jana Ševčíková and Jiří Ševčík; Michael Newman; and Lawrence Rinder. Their great enthusiasm for the project, involvement in shaping the exhibition, and excellent contributions to the

catalogue were all crucial to this project's success. In addition to his acute analysis of Brazilian and Argentine art from the 1960s in his catalogue essay, Herkenhoff also provided invaluable assistance with our search for lenders of art in Brazil. His depth of knowledge of South American artists and their cultural and political contexts, his interest in East European artists, and his familiarity with the challenge of presenting ideas around truly global issues kept the development of this exhibition in focus. We express our enormous appreciation to Ševčíková and Ševčík for their dedication to ICI's mission, as demonstrated by their willingness to share their extensive knowledge of Eastern European artists (both personally and in their catalogue essay), by their diligence in helping to obtain works for the exhibition from lenders in Eastern Europe, and by their generous assistance in bringing the exhibition to the attention of the National Gallery in Prague. We are grateful to Newman for his insightful essay (the second he has contributed to an ICI exhibition catalogue), addressing both the Western European and the North American portions of this exhibition, and illuminating this important period and the artists who helped to shape it. We are delighted that Lawrence Rinder, who is always close to current issues and the work of emerging artists, agreed to write about a group of contemporary artists who in his view have been building on the ideas of the 1960s generation. The catalogue opens with a text by Kalinovska, in which she lays out the conceptual framework for the exhibition and then summarizes a series of formative discussions that she held in the summer of 1999 with Paulo Herkenhoff, Jana Ševčíková, and Jiří Ševčík about the issues they had decided to address in the exhibition. These conversations were based on a group of questions prepared by Rinder that served as an invaluable catalyst and provided a focus for the curator and her colleagues.

ICI owes a tremendous debt of gratitude to several distinguished foundations for their generous support, which helped make this exhibition a reality. The late and much-loved arts patron Penny McCall, through the Penny McCall Foundation, awarded a crucial grant to Kalinovska for her curatorial work on this project, a heartening vote of confidence early in the exhibition's development. The Rockefeller Foundation contributed a significant grant as well as another strong vote of confidence in the project's importance. We are also deeply grateful to Carol

Goldberg and the Foundation-To-Life inc., for their long-standing support of both ICI and Kalinovska. Thanks are also owed to the Trust for Mutual Understanding, which provided a much-needed grant for curatorial research and travel, and to ICI's International Associates, who contributed their support to this most international of projects.

We would like to extend special thanks to Professor Milan Knížák, director of the National Gallery in Prague, and to Katarina Rusnáková, director of the Veletržní Palác, the Collection of Modern and Contemporary Art of the National Gallery. It is especially meaningful for this exhibition to begin its international tour in Prague, and at so distinguished an institution, and we are delighted to have collaborated with them in this way.

In addition to its opening in Prague and its presentations in the United States, *Beyond Preconceptions* will travel to Buenos Aires, São Paulo, and Rio de Janeiro. These presentations in Argentina and Brazil are integral to the concept of the exhibition, and are due almost entirely to Frances Reynolds Marinho and the organization she founded, Instituto Arte Viva. We are indebted to her for her tireless efforts in making these arrangements, for her understanding of this project's impact on South American audiences, and her excitement about its educational potential. By working together, and demonstrating our mutual dedication to bringing significant developments in art to audiences who might otherwise be unable to see such exhibitions, ICI and Instituto Arte Viva created a powerful collaborative force.

This project would not have been possible without the many individual and institutional lenders, listed on page 130, to all of whom we would like to express our enormous appreciation for their generosity and cooperation. We are especially grateful to Meda Mladek, a most important champion of art from Eastern Europe, who welcomed Kalinovska into her homes in Prague, New York, and Washington, D.C., and who gave her access to her immense collection.

Throughout the development of this complex project, we also received important assistance in locating works, facilitating loans, and providing photographs for both the exhibition and the catalogue. In this regard, we extend our sincerest thanks to A/D Gallery, New York; Marie-Puck Broodthaers; Maria del Carmen Zilio, Museu de Arte Moderna, Rio de Janeiro; James Cohan, James Cohan

Gallery, New York; Kathleen Goncharov; Peggy Jarrell Kaplan, Ronald Feldman Fine Arts, Inc., New York; Hiroko Kawahara, New York; Andrea Miller-Keller; Christina Mundici, Turin; Anna O'Sullivan, Robert Miller Gallery, New York; Jack Shainman, Jack Shainman Gallery, New York; Luisa Strina, Galeria Luisa Strina, São Paulo; and Angela Westwater, Sperone Westwater Gallery, New York.

It was a pleasure to work with designers Georgianna Stout and Conny Purtill at 2 x 4, who brought their creativity and intelligence to the production of this catalogue, and with Stephen Robert Frankel, who, in editing several of the texts and as overall project editor, has once again provided ICI with his invaluable skills, professionalism, and keen eye for detail. We would like to thank Lisa Cohen, David Frankel, and Laura Morris for their excellent editing work; Lia Gangitano for assisting Kalinovska with her essay; and translators Izabel Murat Burbridge and April Retter.

Credit must also be given to the entire ICI staff, who contributed their energy, enthusiasm, and professionalism to the production of *Beyond Preconceptions*. We want to express our warmest thanks especially to Carin Kuoni, director of exhibitions, whose sharp eye, acute intellect, and hard work kept the project progressing smoothly. She was assisted by the other members of the ICI exhibition staff: Jack Coyle, registrar, who lent his expertise to the innumerable details of caring for and transporting all the works, and exhibitions assistants Sarah Andress and Jane Simon, who worked on all phases of the project with great care, diligence, and good humor. Thanks also to Angela Gilchrist, former ICI director of development, who carried out complex fund-raising, with the skillful assistance of Colleen Egan, development associate; to the present executive assistant, Sue Scott, and, the former executive assistant, Elizabeth Moya-Leiva, for expediting so many of their tasks efficiently and cheerfully; and to Dolf Jablonski, ICI's exacting and dedicated bookkeeper. Thanks also to ICI's exhibition interns, Gillian Cuthill and Melissa Pomerantz.

Finally, I extend my sincerest thanks to ICI's Board of Trustees for their constant support, enthusiasm, and commitment to all of ICI's activities. They join me in expressing our deep appreciation and gratitude to everyone who has contributed to making this challenging and rewarding project possible.

Judith Olch Richards
Executive Director

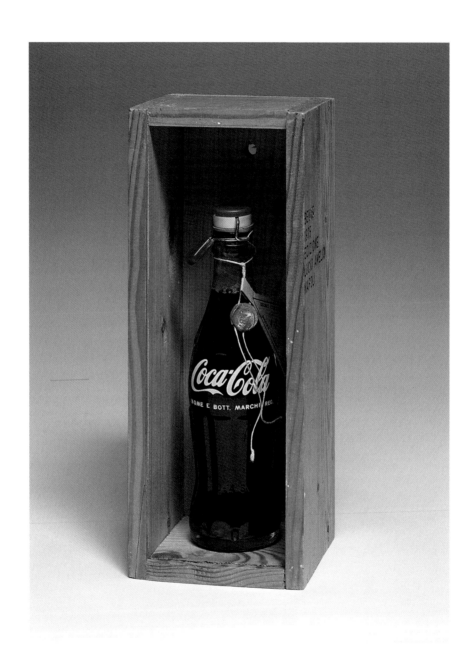

1. **JOSEPH BEUYS** *BRUNO CORA TEA*, 1974
COCA-COLA BOTTLE CONTAINING HERB TEA, WITH LEAD SEAL AND LABEL, IN WOODEN BOX WITH GLASS

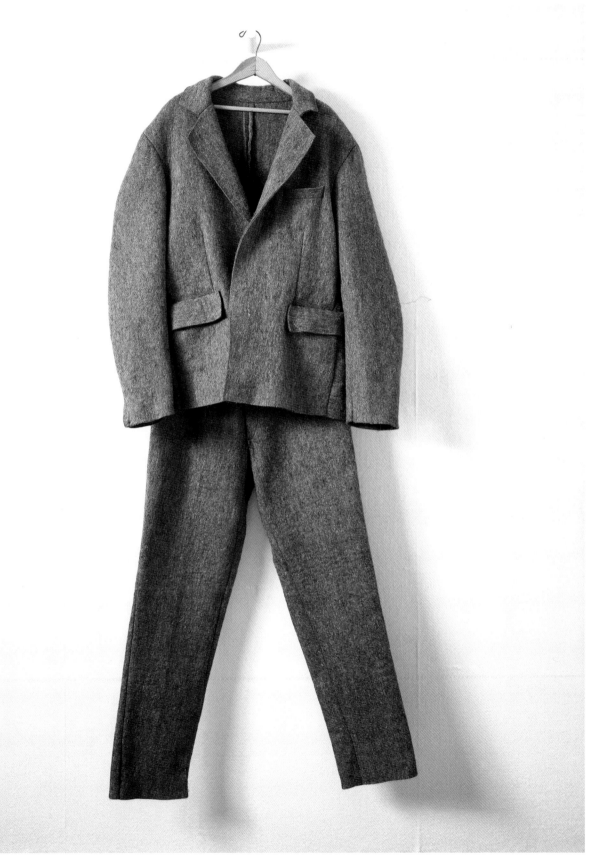

2. **JOSEPH BEUYS** *FELT SUIT*, 1970
FELT

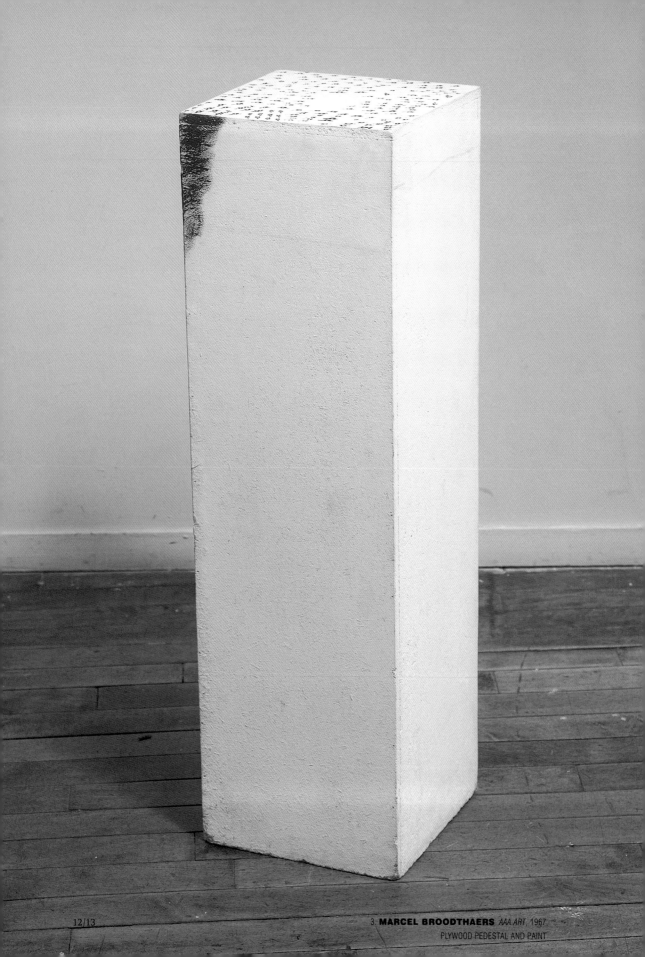

3. **MARCEL BROODTHAERS** *AAA ART*, 1967,
PLYWOOD PEDESTAL AND PAINT

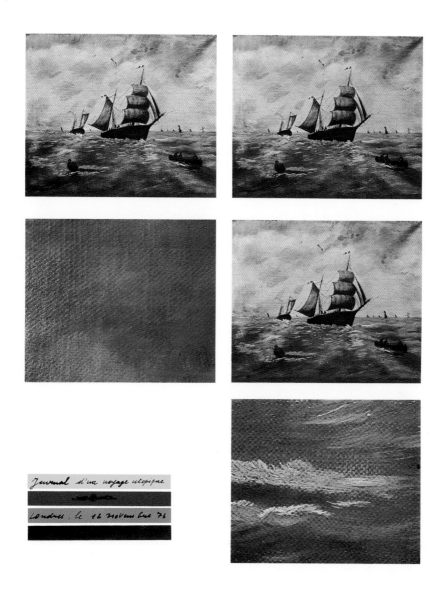

4. **MARCEL BROODTHAERS** *JOURNAL OF A UTOPIAN VOYAGE*, 1973

CHINA INK ON PAPER

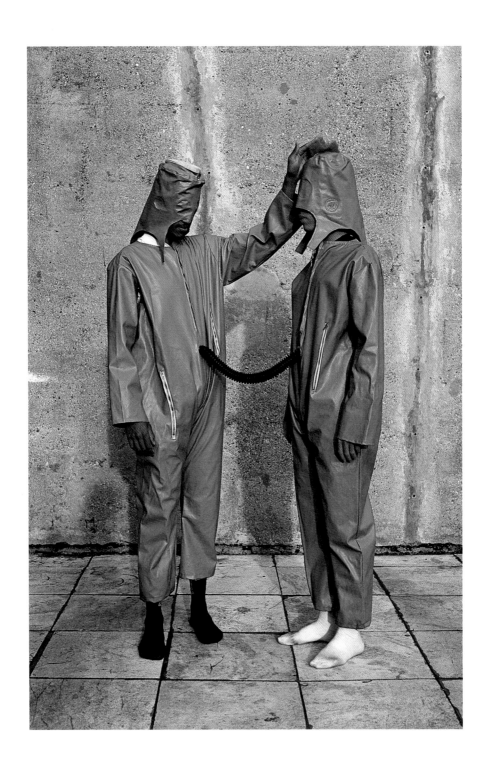

5. **LYGIA CLARK** *THE I AND THE YOU: CLOTH-BODY-CLOTH SERIES*, 1967 (RECONSTRUCTION)
RUBBER

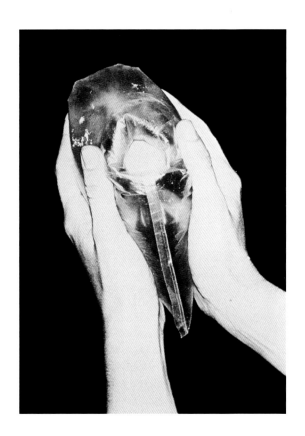

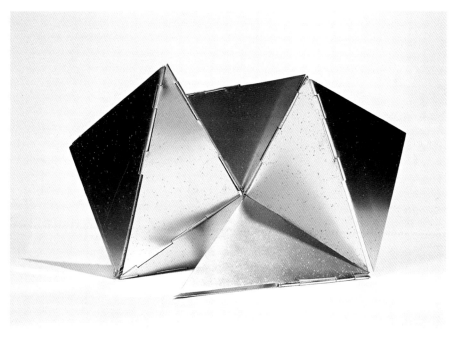

LYGIA CLARK
6. *STONE AND AIR*, 1966, (RECONSTRUCTION) TEN STONES AND PLASTIC
7. *BICHO*, 1966, (RECONSTRUCTION) ALUMINUM

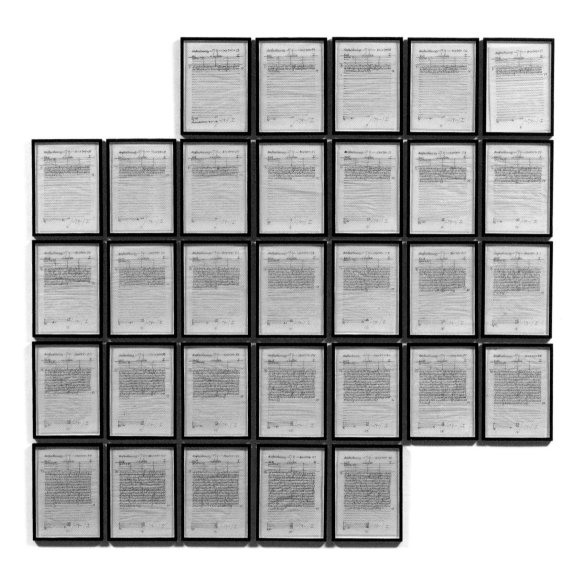

8. **HANNE DARBOVEN** *UNTITLED, 1.1.74–31.1.94*, 1974–94
INK ON VELLUM

9. **HANNE DARBOVEN** *MERRY IS THE GYPSY'S LIFE*, 1979 (DETAIL)
PORTFOLIO OF 31 LITHOGRAPHS

BEYOND
PRECONCEPTIONS:
THE
SIXTIES
EXPERIMENT

I would like the work to be non-work. This means that it would find its way beyond my preconceptions. What I want of my art I can eventually find. The work must go beyond this. It is my main concern to go beyond what I know and what I can know. The formal principles are understandable and understood. It is the unknown quantity from which and where I want to go. As a thing, an object, it accedes to its non-logical self. It is something, it is nothing.[1]

— *Eva Hesse*

In Brazil, the roles take on the following pattern: how to, in an underdeveloped country, explain and justify the appearance of an avant-garde, not as a symptom of alienation, but as a decisive factor in its collective progress? How to situate the artist's activity there? The problem could be tackled by another question: who does the artist make his work for? It can be seen, thus, that the artist feels a greater need, not simply to "create," but to "communicate" something which for him is fundamental, but this communication would have to be large-scale, not for an elite reduced to "experts," but even "against" this elite, with the proposition of unfinished, "open" works.[2]

— *Hélio Oiticica*

In the remnants of the triumph of the war,
what might be termed a cycle with a paltry
period, there emerged a group of black
paintings called *paysages de la guerre*, after
them came simply *paysages.* They could
in professional terms be called *"pure land-
scapes"*, and then they evolved into *"assorted
landscapes."* If art does not stem from a
concept but from a material state, then the
state in which these metamorphoses of
death were created could be seen as a cer-
tain loosening of the pressure from the tri-
umph of war. From the emptiness of despair
something like thoughts began to emerge.[3]

— *Mangelos*

The work of art is rooted in the unconscious,
which we understand as an impersonal
psyche common to all men, even though
it manifests itself through a personal
consciousness (hence derives the possibility
of the artist-work-viewer relationship).
Each person draws his humanity from the
substratum without realizing it, in a simple,
immediate way. [4]

— *Piero Manzoni*

Beyond Preconceptions: The Sixties Experiment includes artists from Eastern and Western Europe and the Americas, and one, On Kawara, who lives in New York and Tokyo. They all share similar sensibilities and histories, and simultaneously developed new models of art making that moved away from the traditional object, and—if not for geo-political circumstances—might have exhibited together since the 1960s as they responded in parallel modes to a larger global condition. Because of the boundaries between East and West, North and South, they have not. Working in different economic and political systems, many of these artists have addressed issues related specifically to their immediate milieu. The opportunities to have their works seen and discussed at home and abroad, or the works from other cultures seen in their own country, have varied greatly. Although it has been possible, especially recently, to achieve a more "global" perspective in the United States and in Europe, the work of artists from Eastern Europe and South America has appeared there infrequently, whether in exhibitions or in the critical discourse of the art media.

For decades, the countries of Eastern Europe were closed to international exchanges, and art was practiced in politically repressive situations. The artists who lived there existed without the support of museums or art publications, and those who experimented and did not conform to official doctrine remained on the margins of their society and suffered a nearly complete lack of international exposure. Since the disintegration of Soviet Communist hegemony at the beginning of the 1990s, artists have faced another challenge: the issue of control over defining the "identity" of their art in a "united" Europe. In an exhibition held in 1998, *Body and the East/From the 1960s to the Present*,[5] curators and writers from fourteen Eastern European geo-political areas attempted to address their shared "separateness," and affirmed their "otherness" as a strategy against the homogenizing effect of globalization. They acknowledged, however, that to the West, "European" still usually means Western European.

Works by artists from South America have also been closely tied to their nations' complex political and economic situations. However, their contribution has achieved global visibility, and its importance has been recognized, in the context of non-Eurocentric interpretations of the history of art—for example, by Paulo Herkenhoff in the *XXIV Bienal de São Paulo*, held in 1998. In this large, international exhibition, chief curator Herkenhoff and his team made all the works, whether known or unfamiliar, historical or contemporary, speak in new ways, from the point of view of South American experience, affirming "the inescapable and utterly simple fact that we need the Other in existential experience."[6]

The large-scale 1999 exhibition *Global Conceptualism: Points of Origin, 1950s–1980s*[7] and

publications such as *Rewriting Conceptual Art* [8] are part of a re-examination of Conceptual art as a mind-set that grew out of, and has built on, the early-twentieth-century avant-garde. The artists involved moved beyond painting and sculpture to create new approaches to making art: non-objective work abandoning representation, utopian movements such as Constructivism promoting new forms of art and new roles for artists, strategies of the readymade, the use of non-art forms and systems, and so on. *Beyond Preconceptions: The Sixties Experiment* looks at the similarities and differences of twenty-one artists, some of whom had already begun exploring these non-traditional approaches in the late 1940s, a tendency that reached defining momentum in the 1960s and early 1970s and led to the break with modernism. These artists questioned the very notion of art as they experimented with alternative modes of artistic production; worked with nontraditional materials that suited their idea-based production and moved outside of conventional situations; challenged the understanding of what art can be and redefined its role in a broader cultural framework; and searched for freedom from market forces and ideology while reshaping the role of the audience. They built on shared knowledge, yet they were articulating their own critical frameworks as individual artists, often quite separate from one another. Although the artists included in this exhibition are all associated with Conceptualism, each

artist faced a different challenge and responded in a singular way. The focus here is on their common pursuit of understanding the meaning of certain aspects of everyday experience and the significance of the material object within that experience.

For this exhibition catalogue, I have asked five writers to offer their perspectives in essays addressing their particular areas of interest and knowledge. Michael Newman has a deep understanding of the legacy of experimental art, especially that of Western Europe and North America. Jiří Ševčík and Jana Ševčíková have thought about and written extensively on the challenges of Eastern European artists. Paulo Herkenhoff has evaluated art from South America in the expanded context that this exhibition presents, and Lawrence Rinder considers the current interest among younger artists who acknowledge links with this radical period.

While working on the exhibition, I met with Paulo Herkenhoff and Jana and Jiří Ševčík in July 1999 in Prague for a discussion of various aspects of the exhibition, based on questions prepared for us by Larry Rinder, which we used as starting points to share our observations about the visual arts of these regions. Because our exchange was informal and conducted in English, with frequent interruptions as we translated and reinterpreted each other, and since none of us are native English speakers, I have summarized our conversation rather than presenting it verbatim.

Why does this exhibition focus on the constellation of Eastern Europe, Western Europe, North America, and Latin America? What is the rationale for disregarding Asian and African Art?

Whatever we do, we always make choices and we are always subjective. The exhibition is not a portrait of the world. It tries to achieve a balance between selected artists, to show what was happening at a certain time across much of the world. The exhibition does not address one particular issue or style, but rather a set of attitudes and ideas that connect these artists. It is an intimate exhibition, not a survey, about artists whose values are rooted in Western civilization and who, despite encountering different sociopolitical conditions, shared certain ways of thinking at a certain moment in history. They did not work in isolation, but developed their art in the context of a cultural process that includes not only art but also literature, theater, film, music, and architecture.

Art in Eastern Europe and South America has tended to be judged according to the dominant aesthetic of Western Europe and the United States. It is even claimed that artists from Eastern Europe and South America have only recently been discovered. This brings up a key question: Who needed to forget many years ago, and who needs to remember now? What is important here is not simply to present new works, but to open viewers' eyes to the "other."

How is the mixing of art from different regions being understood? Can it, perhaps, be seen as an expression of Brazilian "precariousness," an opportunity for what Lygia Clark called "an exchange of psychic qualities?" or a challenge to Jiří Kolář's statement that "great works of art withstand even mutilation"?

An exhibition is not a formula that applies to every artist, but it demonstrates how artists can be extremely different and yet still have something fundamental in common. Art movements happen because of historical conditions in one place and not elsewhere; but they are not reflections of nationalism or regionalism. Rather, they become a cultural moment of certain communities. For example, in Brazil during the 1940s, Concretist artists were invited to work as therapists with patients at psychiatric hospitals and were confronted with the patients' world of fantasies. There was a desire for rationality and at the same time an openness of the soul, a strange combination whereby subjectivity comes from extreme rationality, and therefore poetry from calculation. This had an impact on artists such as Hélio Oiticica. At this time, the theory of the non-object was articulated: the object that leaves no trace, just your experience of it. Despite being called a "non-object," it still refers to the material world, as in the work of Lygia Clark, who called herself a non-artist, but continued to make art. Similarly, Croatian artist Mangelos called his body of work "noart,"

as he found it necessary to build art anew. Eva Hesse declared that she liked her work to be "non art," as she pushed for "nothing, everything, but of another kind, vision, sort." John Latham used the term NOIT, for "non-object," calling it a strategy for production. Jiří Kolář built a whole new understanding of reality through "destroyed and stabbed poetry or silenced book." Marcel Broodthaers makes us re-evaluate the significance of art by considering art "as useless labor, apolitical and of little moral significance." The 1960s was a period of renewed creative energy that challenged commonly held beliefs with new strategies, offering engaging relationships that the public can have with art. The term "postmodernism" was first used by Brazilian critic Mario Pedrosa in the mid-1960s. He said that modern experience and vocabulary were exhausted, and that there was a need for a new level of communication, new ways of presenting things to society, which he called postmodern, and which some artists were already beginning to develop. Finally, he asserted that at the time of crisis it is important to be *with* the artist, not *against* the artist. His non-aesthetic definition of art as the experimental exercise of liberty is at the center of Brazilian creative expression.

Clark said, "The instant of the act is not renewable." How will this exhibition renew the act? Or will it be a kind of archeology or cabinet of curiosities?

We are making the point by connecting the issues of the 1960s to today's issues—such as an artist's relationship to and understanding of material, and the desire for its disappearance (i.e., dematerialization), or making work come alive through viewers' participation. The question of dematerialization was important to artists such as Lawrence Weiner. A shift of emphasis toward participation and experience as a way of giving new meaning to material took place among Brazilian artists, such as Lygia Clark, who was interested in interior space and psychological perspectives of the senses (inward), and Oiticica, who was interested in color and anthropological interrelationships between people (outward). Eastern European artists invested their materials with an emotional, autobiographical dimension, while living in a reign of half-truths and with no public audience for their art. For Mangelos, "the only civilized approach to the world is speech-thinking; the others have been exhausted."[9] He was eliminating painting in a slow, intuitive search for a non-obsolete spiritual model of interaction. Similarly, Jiří Kolář connected texts, pictures, and objects of his choice in order to convey multiple realities that he hoped would lead to a spiritual understanding of life.

Guy Brett writes of "common patterns that arise in attitudes toward experimental art." What are some of these common patterns as expressed in the works in this exhibition?

Our responsibility is to create an exhibition where an element of participation is obvious and available to the viewer. The everyday life of the exhibition belongs to the institution, and we should convey this aspect of the exhibition clearly. The kind of interrelationships that exist among the works, we shall see in the exhibition itself. We want to respect the works for what they are and present them in the way the artists meant them to be shown or used. These works can only be comprehended in our time. However much they may speak about the past, at present they testify about our time. Our intention is to avoid historical interpretation, because however close you want to get to the work, you cannot see it in the same way as the artist did. We have a different understanding of the concept of freedom now. Artists had to choose positions and models of freedom against dictatorships, regimes of oppression, confrontations, and so on. Where Guy Brett speaks of patterns, maybe instead we can try to find dialogues and relationships. Patterns can become traps. So let's turn to the dialogue in which similarities and differences have the same value. Once we find the similarity, immediately the next question should be, Why is there difference? If we give so much weight to history, we ask why history is important for the present, why artists did a certain thing, and what was their dream. The past per se should not be a cage to the present; it is up to us to connect it more meaningfully with the present.

It seems that the experiment and courage in art is, for pretentious people, more dangerous than anything else. Begin to think for yourself and you are more threatening than anything that can be made. All the power of art and literature is above all really based only in shifting something into a new field of perception.[10]

— *Jiří Kolář*

Will the men of tomorrow live their lives with the same feeling? Probably not, as they will lose this Utopian hope of the "future." They will be the very "future" itself. [11]

— Lygia Clark

1. Hesse, quoted in Germano Celant, *Arte Povera* (Milan: Gabriele Mazzotta Editore, 1969), p. 56.

2. Hélio Oiticica, "General Scheme of the New Objectivity" (1967), in *Hélio Oiticica*, eds. Guy Brett, Catherine David, Chris Dercon, Luciano Figuerido, Lygia Pape; (Minneapolis: Walker Art Center; Rotterdam: Witte de With, 1992), p. 119.

3. Mangelos, quoted in Branka Stipančić, *Dimitrije Bašičević Mangelos* (Zagreb: Muzej Suvremene Umjetnosti, 1990), p. 13.

4. Germano Celant, *Piero Manzoni*, (London: Serpentine Gallery; Milan: Edizioni Charta, 1998), p. 68.

5. Zdenka Badovinac, *Body and the East / From the 1960s to the Present* (Ljubljana: Museum of Modern Art, 1998).

6. Paulo Herkenhoff and Adriano Pedrosa, "The Carioca Curator," *Trans> arts.cultures.media*, no. 6 (1999), p. 15.

7. Luis Camnitzer, Jane Farver, and Rachel Weiss, *Global Conceptualism: Points of Origin, 1950s–1980s* (Flushing, New York: Queens Museum of Art, 1999).

8. Michael Newman and Jon Bird, *Rewriting Conceptual Art* (London: Reaktion Books, 1999).

9. Mangelos, quoted in Branka Stipančić, *Dimitrije Bašičević Mangelos*, p. 18. This passage was translated from the Croatian by the author, Stipančić.

10. Jiří Kolář, *Odpovedi* (Cologne: Index, 1984), p. 10. This quoted passage was translated from the Czech by Milena Kalinovska.

11. Clark, quoted in Manuel J. Borja-Villel et al., *Lygia Clark* (Barcelona: Fundació Antoní Tàpies, 1997), p. 159.

Independent curator *Milena Kalinovska* was director of the Institute of Contemporary Art (ICA), Boston, from 1991 to 1997, where she organized such exhibitions as *New Histories* (focusing on nine artists who challenge the established historical narratives of their respective "majority" cultures) and solo exhibitions of work by Cildo Meireles, Bill Viola, and Rachel Whiteread.

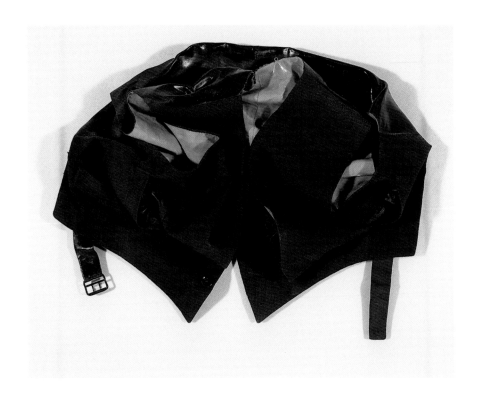

10. **BETTY GOODWIN** *CRUSHED VEST*, 1971
FABRIC TREATED WITH RESIN, AND PLEXIGLAS

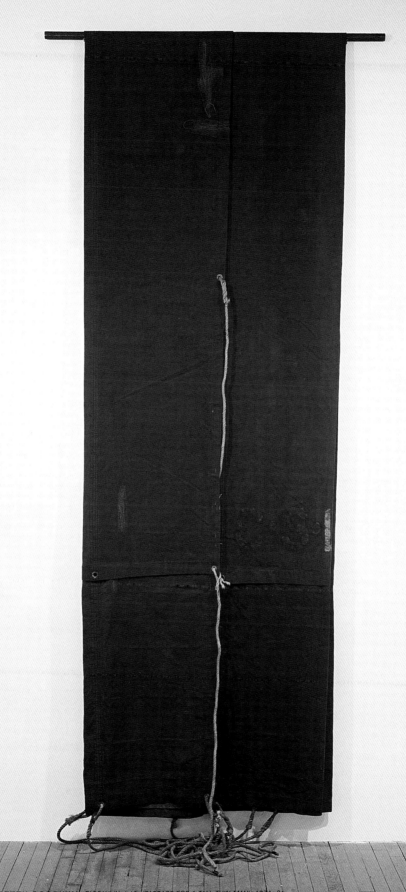

11. **BETTY GOODWIN** *TARPAULIN #10, (PASSAGE FOR A TALL THIN MAN), 1974–91*
TARPAULIN, OIL, STAPLES, AND CORD

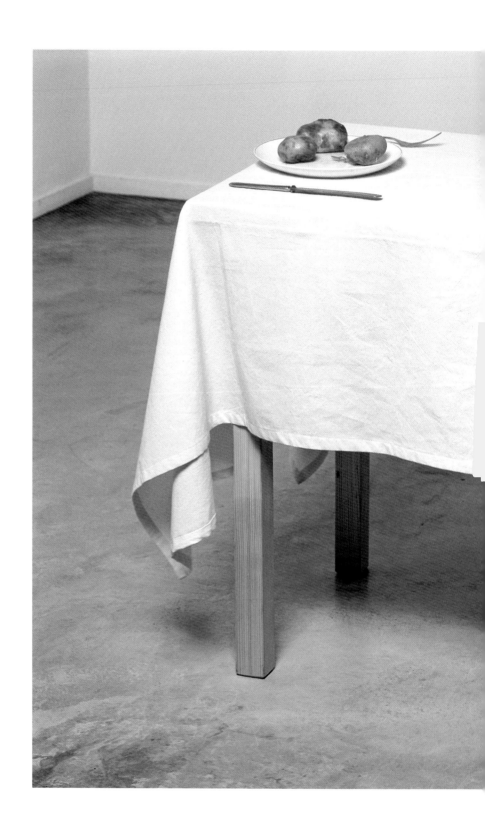

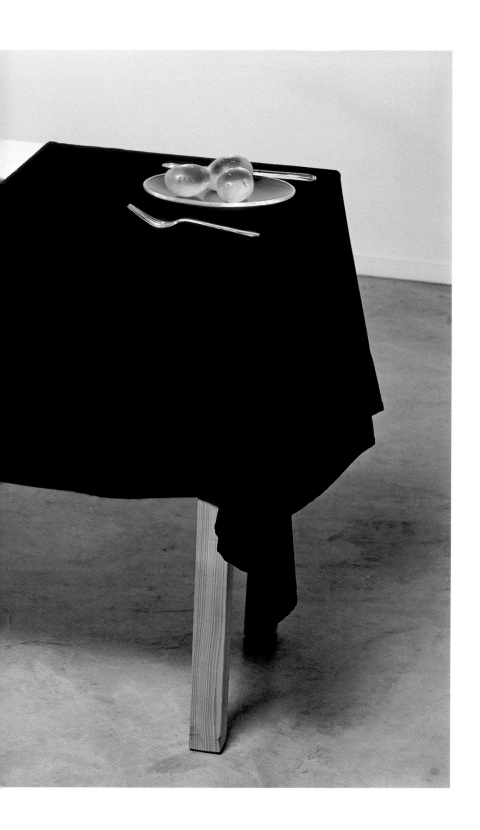

12. **VICTOR GRIPPO** *Analogy IV*, 1972
POTATOES, PLATES, KNIVES AND FORKS, TRANSPARENT PERSPEX POTATOES,
WOODEN TABLE, AND TABLECLOTH OF WHITE COTTON AND BLACK VELVET

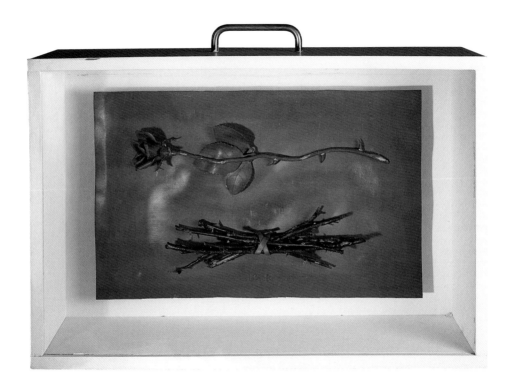

13. **VICTOR GRIPPO** *IGNE*, 1979
ROSEBUSH TWIGS, LEAD ROSE, LEAD SHEET, GLAZED WOODEN BOX, AND METAL HANDLE

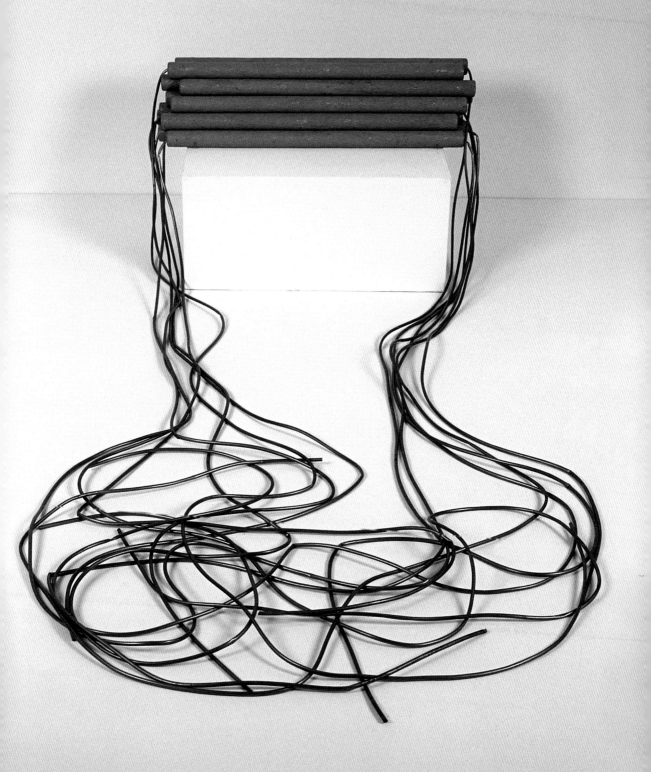

14. **EVA HESSE** *MODEL FOR ACCRETION*, 1967
TWENTY PAINTED CARDBOARD TUBES, METAL WASHERS, SCULPMETAL, AND SIX VINYL CORDS

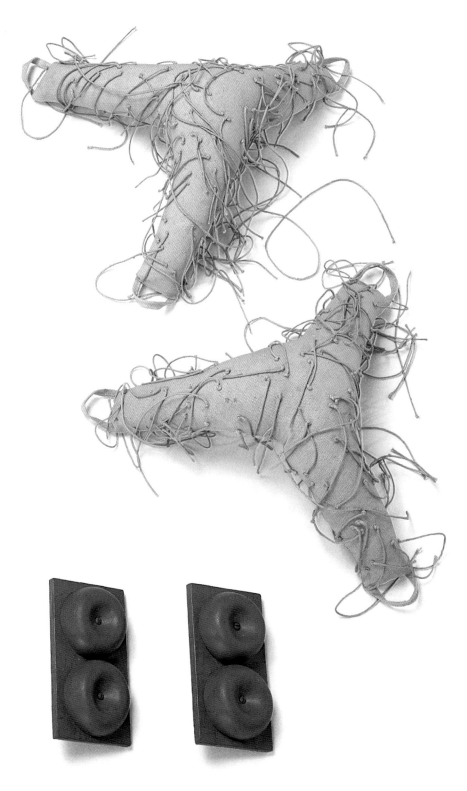

15. **EVA HESSE** *TEST PIECES*, 1966–69 (DETAIL)
MIXED MEDIA

THE SIXTIES AND THE EAST

JIŘÍ ŠEVČÍK AND
JANA ŠEVČÍKOVÁ

Following the fall of the Berlin Wall and the release of the Eastern bloc from Soviet domination, the West found in this region a "difficult territory" of a different civilization and turned to it in search of new energy and the possibility of regenerating its own culture. The traumas caused by the clash of these two geo-cultural zones, with their different histories, myths, ghosts, and "residual problems," continue to raise certain questions: Should the art of the Eastern bloc integrate, assimilate into the universal system of the West? Will it be colonized? Which will prevail—strategies of resistance or of adaptation? How will the East absorb the West—in a cannibalistic feast (the cannibal effect), or by adapting to it and coming to resemble it?

The very formulation of these questions reveals some unexpected similarities between the situations of Eastern and Central Europe and certain culturally and geographically distant areas, such as South America, another part of the world that the West has "discovered" as a stimulating force. There, too, a post-colonial debate about resistance and strategies is under way, about how to absorb the differences in the clashing cultures' central images (including the cannibal myth, a special form of cultural resistance of the periphery toward the center).[1] A persistent problem in this region is the common myth of the authenticity of the periphery, and the West's tendency to reduce all artists here into a single poetic construct of the "Eastern or Central European artist." (And this is without bringing up the question of the even more different former Soviet Union.) The similarities among all the different cultures in this region are in fact secondary to the problems that have surfaced in the gap "between," which is perhaps the very space by which all of us will come to measure ourselves and to define our new identity. Perhaps all we have in common is our focus on the question of the definitive disappearance of certain values and programs. But our relation to the avant-garde and late modernist currents, and the increasing tension between the two in the 1960s, still has an important role to play.

In the formerly Communist countries of Central Europe, the avant-garde was in crisis even before their integration into the Eastern bloc. After the experiences of World War II, there was a general feeling that the modern age had come to an end, that there was a lack of new ideas that could give real meaning to society and its culture. The utopia of the avant-garde became an empty historical construction, and intellectual circles were faced with the dilemma of choosing between socialism or Western-style democracy.[2] At the same time, it was realized that modern art would be beyond the understanding of the new society, as such art had shut itself into an aesthetic realm that was external to society and had become overly academic. There was a general hope that the socialist society would bring art back to life, even at the cost of turning it against itself and against the values that had guided it until then. Some tried to resolve the conflict by including art inside society, but in a safe place where it could freely regenerate itself. In this way, art would be autonomous and yet close to everything that lies outside it.[3]

The relation of the official Socialist Realism and the unofficial modernism to the avant-garde differed widely in Russia and the countries of Central Europe. While for the latter, the most urgent task after Stalin's death was to uphold the modern tradition and to bring the suppressed modernist culture back into the public eye, the prevailing attitude in Russia was anti-modernist, and art showed a definite retrospective conservatism. There, hatred of the West and its ideas of unlimited progress still reigned strong, and the judgments of the 1920s remained unquestioned.[4] At the same time, the avant-garde in Russia (as in the other Soviet bloc countries under the Communist regime) suffered a double defeat: on the one hand from the party apparatus, with whose policies it came into conflict and competition, and on the other from the tamed modernists and traditionalists who accused the avant-garde of collaborating with the powers that be and who were themselves accused by the avant-gardists of being reactionary and counter-revolutionary artists. The relationship between official and unofficial art in the 1950s and 1960s was a direct result of this.

In the late 1950s and early 1960s, the most progressive wing of unofficial Russian art, the so-called post-utopian art, could not go on with the avant-garde project that had become so perverted by power, or with the conservative moves

toward reviving the collective myth of the pre-modern.[5] Its theme was the analysis of the ideological strategies of the avant-garde and modernism, as well as of Socialist Realism and postmodernism. Artists could leave behind the world of utopian ideas of the "new man," but could not rid themselves entirely of reality (even as its presence in their works was steadily decreasing), just as it was not possible to return to natural space. Ilya Kabakov, in his albums of drawings and texts (such as *10 Characters/Album: The Flying Komarov*, 1972, [plate 17]), featured many examples of "communal babble," written fragments of conversations and complaints from com-munal apartments that break through the empty space and do not in fact correspond to anything real, only to other words and texts devoid of meaning. It is the only reality, hovering in the impenetrable nothingness of Malevich's black space and affirming the traditional nominalism of Russian thought.

Kabakov takes this idea even further with works that incorporate dirt, waste, and rubbish, such as *Box with Garbage*, 1972 (plate 16 and fig. 1). Like the "communal babble" he presented in his albums, this affirms the diminution of art's subject—that turning away from the heroic and utopian themes, and their replacement by the banal and the seemingly worthless. Here, things are freed from having to relate to something; they have only a name, and that is what gives them their identity and the possibility of existing in themselves. The backdrop of the ultimate reality is the space of emptiness, which should have been the setting for the construction of the

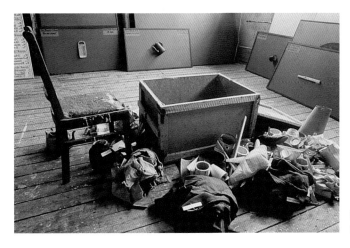

FIG. 1. **ILYA KABAKOV** *BOX WITH GARBAGE*, 1972
WOODEN CHAIR AND BOX, AND FOUND ITEMS

final act of history for modern man. Communication is only possible in this space if we touch the discarded objects and listen to the overheard fragments of conversation, which preserve the last remains of human social reality for us, and thus prevent us from confronting absolute desolation.

However, within the Central European peoples' democracies, many left-wing intellectuals sought the missing impulse in socialism, and tried to preserve modernist traditions for it. In Czechoslovakia at that time, the last avant-garde program based on dialectical materialism survived alongside socialism. It had already reached its definitive form before the war, and Karel Teige, the greatest figure of the Czechoslovak avant-garde between the wars, continued to follow this in complete isolation until his death in 1951.[6] Teige's lyrical view of the world and the Hegelian hegemony of poetry became the platform of a Surrealist group that was forced underground after the war. The strong position of this official representative of unofficial art was attractive after the post-Surrealist trends followed a basically anti-avant-garde and anti-modernist platform, and became an obstacle to all attempts at dematerialization and conceptualization. This was a result of external influences and did not correspond to the internal situation. How then was it possible to continue with the avant-garde project in a time of its failure and double defeat?

The iconoclastic change came with a group of artists who managed to bring together avant-garde sources with a new construction of paintings, utilizing "cooler" media and objective approaches. Jiří Kolář was one of the main catalysts of this period. He harked back to the pictorial poems of Czech poetism of the 1920s as one of the main products of the avant-garde, but gave it a new meaning. He worked consistently with the immanent elements of the poetic language, which, in this fragmented form, acknowledged that poetry is not enough for what war brings, in the face of which all literature is merely babble.[7] Kolář also became aware that literature is an instrument of the repressive power of society, as Claude Lévi-Strauss pointed out in *Triste Tropiques*: "The primary function of written communication is to ease the path of enslavement. Using letters for unselfish ends, for intellectual and aesthetic satisfaction, is only a secondary result."[8] Kolář returned to the pre-poetic and pre-semiological stage and offered an alternative not only to the ideology of state power, but also to tamed modernism. A sense of the end of literature

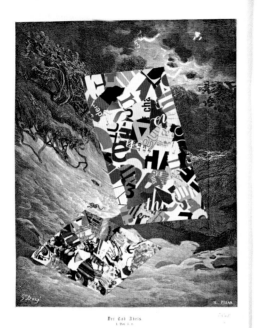

FIG. 2. **JIŘÍ KOLÁŘ** *THE DEATH OF ABEL*, 1960
COLLAGE ON PAPER

led Kolář to exclude even the written word and to replace it by found objects so that words, as he put it, were left only in people (see, for instance, *Black Sugar*, 1963 [plate 19]). Kolář called this "evident poetry." He set out to systematically develop an enormous number of different techniques and methods to achieve this aim, listing these in his "Dictionary of Methods," the last edition of which had 246 entries.[9] Like the heap of everyday items in his objective poems, these different methods always aim at objectifying the work to take away its traditional content, as is evident in *Death of Abel*, 1960 (fig. 2). A second form of concrete poetry, Kolář's "de-static poetry," retained something of the avant-garde idea of influencing life and is a close parallel of Action art and Happenings. The de-static poetry in the collection entitled "Instructions for Use"[10] recalls the short descriptions and scenarios of the late representatives of Action art, Happenings, and Fluxus. Both the declaration of the end of literature and the subsequent need to reconstruct it from the beginning so that it cannot be exploited again, served to place Kolář in front of an empty space, which he then covers using the method he called "chiasmage," as in *Journey to the Center of the Earth*, 1966 (plate 20). He strips away all the rules of writing and logic that separate the image from the letter. Only fragments of text and shreds of convention remain. These are neutralized or completely emptied of their original meanings through their inclusion in the collage. The artist lets them fill the emptiness. This form of spatial scenario, a disintegration of meaning far from a subjective point of view, was a very personal experiment of the 1960s. However, Kolář, as a European artist, probably

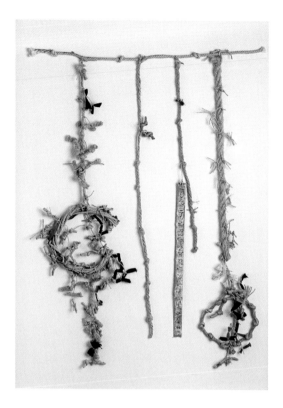

cannot detach himself from the avant-garde idea of universal poetry, which endows
its de-subjectivized space with an aura of synthesis and illusion that is capable of
transcending the remains and waste of history.

In the former Yugoslavia, the forces present on the artistic scene had a very
similar disposition to that of Czechoslovakia or Poland. In Poland's more liberal
regime, art was more autonomous, and "socialist modernism" was accepted as state
art, even in its abstract form. In the 1950s, there were small groups of artists working
on its outskirts, most of whom had no interest in politics and found various ways
of defining the empty space they were faced with. One of the most original members
of the Gorgona group in Zagreb, Dimitrije Bašičević Mangelos, was, like Kolář,
convinced that poetry could not survive World War II.[11] The role of the artist,
Mangelos declared, is to teach people to speak again after the end of the world,
when art can no longer help them; the path to language leads through nothing-
ness.[12] On Mangelos's black tablets (among them *Manifesto about Thinking no. 1*, 1978
[plate 32]), ideas and words emerged to renew the clarity of thought. They discarded
existential emotion, replaced the irrational load of images, but could not escape
from irony and absurdity. Mangelos's tablets, books, and globes (see plates 32–35)
are generally self-referencing about the language of artists and philosophers;

as he once said, "The only cultural approach to the world is speech-thinking, the others have been exhausted."[13] Mangelos's lifelong project, "noart," was an attempt to re-enter the unfilled space, installed before the triumph of emptiness.

At the beginning of the 1960s in Czechoslovakia, Karel Malich joined Kolář in the iconoclastic move from "Prague neomodernism, Surrealistic expressionism, searching for a synthesis in the language of the baroque effects of materials," as described by Pierre Restany.[14] In the 1960s, Malich rejected the "apocalyptic narrativity" of contemporary art and the anthropological view of the world. He had a hypersensitive view of people and the environment, and was excited by the human figure and what lies behind it. In one interview, he described this backdrop as "an unknown crushing space. A place where nothing can be done. A glimpse of the unknown but understandable cosmos. Man without violence but respecting everything."[15] The gesture of the turn to the forces from without was also a gesture against the figurative and its power. Kolář wrote that the traditional structure of poetry is of "knots of power which enslaves" (see also his *Poem of Knots*, 1963 [fig. 3]). Malich's wire sculptures, such as *A Tree*, 1976 (plate 31), also have a knot structure; however, they are knots that transmit energy in the impersonal power fields. All the materiality necessary to represent energy is reduced to lines of wire. For him, these were analogies of energy, extensions of the sensory perception of energy. They could be expanded to cosmic dimensions that delineate the non-apocalyptic emptiness.

In Poland, Edward Krasiński developed a highly radical combination of avant-garde traditions and the changes of the 1960s. The iconoclastic gesture and his distaste for existential analyses led him to make objects that became functions of space and light, creating situations that the viewer must become part of (see fig. 5, showing the artist performing *J'ai perdu la fin!!!*, 1969). The suspended sculptures have no content; they are consistently dematerialized, hovering weightlessly in space. Behind them lies an immense weight of a Dadaist sense of the absurd deviation from the norm, but also a sensitivity to energy from without, as in Malich's work. Krasiński began by arranging various groups of objects such as cylinders, coils, bottles, and even books and suspending them by vinyl cords, strands of wool, or wires, as in *H6*, 1968 (plate 22), and *ABC*, 1970 (plate 21). Gradually he moved toward greater and greater dematerialization, reducing these containers and conductors

of energy to simple lines emphasized by the symbolic color blue, as in *Zyg-Zag*, 1970 (fig. 4). At first, Krasiński eliminated the objects, leaving just the cords and painting them blue (a last remnant of the figurative gesture of traditional painting), as in *J'ai perdu la fin!!!* Then, he found some rolls of commercial 19mm (3/4 inch) blue tape and—using a dimension related to the human body—applied the tape horizontally on walls at a height of 130 cm (51 1/8 inches), which is about chest level. The blue adhesive tape was self-supporting and needed no other construction or material besides the wall. His often-quoted, laconic explanation of this was, "IT intervenes INTO and exposes THAT. IT exists. I trust IT."[16] Krasiński's explanation can perhaps be seen as saying that this object that does not represent anything, which is reduced to pure line, intervenes in the chaos of empty space, bringing order to it and giving meaning to things submerged in it. The objects inhabiting everyday space, walls, furniture, or installations attain a new significance when the blue tape draws them into the situation and charges them with a current of energy.

There are just two more issues to add to the key questions of this report on the 1960s in our countries of Eastern and Central Europe. One relates to the change in sensibility and the way things were perceived. In contrast to the traditional idea of the fullness of meaning, constructed from within, there was now an idea of the inexhaustibility of meaning, derived from the "meaninglessness" of the art object. New objects placed in impersonal situations and removed from the concept of quality were a change that the public in the East found difficult to cope with. The external-

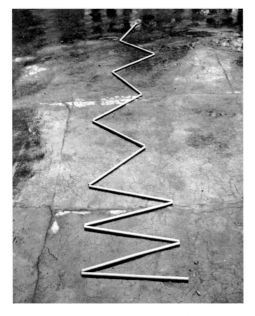

FIG. 4. **EDWARD KRASIŃSKI** *ZYG-ZAG*, 1970
WOOD AND OIL PAINT

ABOVE RIGHT:
FIG. 5. **EDWARD KRASIŃSKI** *J'AI PERDU LA FIN!!!*, 1969
PHOTO DOCUMENTATION OF PERFORMANCE WORK

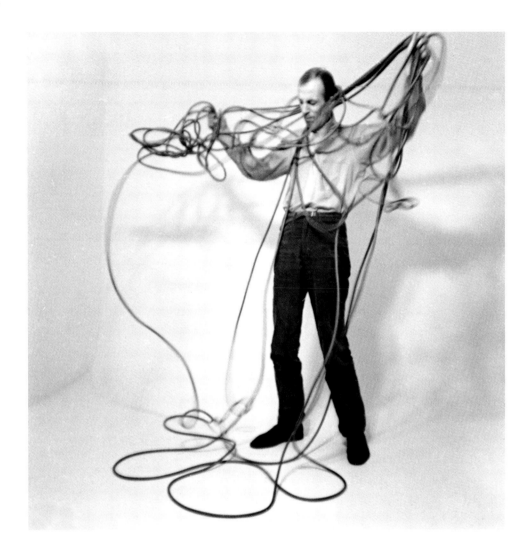

ization of meaning and the stress on forces acting from without attacked the surviving remnants of European modernism. By doing so, the artists of these works were in fact discovering a different form of freedom, with the art as an end in itself, but it was hard to maintain such a state of self-reference. Even the most radical outsiders, unlike their Western counterparts, continued to endow their works with the greater integrity that traditional art methods suggest, and many of these works were in some degree autobiographical and therefore less objective.

The second issue is the problem of art as a mechanism of resistance. This was stated very well by Polish art historian Piotr Piotrowski as a defense of the "supra-historical" ("supra-ideological") values of art, which when "fossilized in the 'conservative' ('modernist') values of artistic autonomy became a weapon of anti-totalitarian resistance."[17] Such mechanisms of resistance were perhaps effective in their time, but the fundamentally aesthetic basis of art, like the directly ethical basis of politics, was one of the causes of the decline of art's moral focus and the

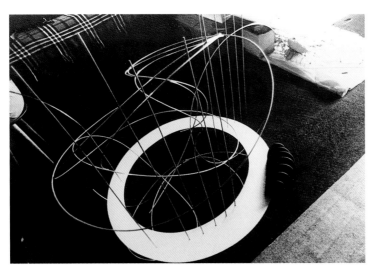

FIG. 6. **KAREL MALICH** *THE BLACK CLOUD*, 1973
PAINT, ALUMINUM, STAINLESS STEEL, AND WIRE

neutralization of art's social function. According to Slovenian philosopher Slavoj Zizek, the former proponents of the philosophy of "life in truth"—or of "the power of the powerless," as expressed by Czech president Václav Havel—have rechanneled their energy into excessive moralizing. Zizek refers to how the West's armed intervention in Kosovo was legitimized by Havel's depoliticized appeal for universal human rights.[18] The inertia and perversion of some mechanisms of resistance in the post-totalitarian countries are undoubtedly also a legacy of the 1960s and of the relations between East and West, and need to be analyzed in much greater detail. Seen from within, the East-West problem still remains. Art from the East is interesting to the West so long as it is compatible with Western work, or is a result of the sacrifices of the victims of another regime. It seems that, following the collapse of the alternative, there is no route other than integration. But in this context, it is essential to construct a new identity and an alternative method for survival.

1. See Paulo Herkenhoff, "Having Europe for lunch: a recipe for Brazilian art," *Poliester 2*, no. 8 (1994), pp. 8–15.

2. See Jindřich Chalupecký, "Konec moderní doby" (The End of the Modern Era), *Listy Magazine* (Prague, 1946), pp. 7–23.

3. Ibid., p. 22.

4. See Boris Groys, *Gesamtkunstwerk Stalin: Die gespaltene Kultur in der Sowjetunion* (Munich and Vienna: C. Hanser Verlag, 1988), p. 19ff.

5. Ibid., p. 83ff.

6. See Teige's account of the final version of this program in texts after World War II in his *Osvobozování Života a poesie, Studie ze 40. let* (Liberating Life and Poetry: Studies from the 1940s) (Prague: Osvobozoání Zivota, 1994).

7. See Jiří Kolář, "Snad nic, snad něco" (Maybe Nothing, Maybe Something), *Literární noviny* no. 36 (Prague 1965), pp. 6–7. See also Jiří Kolář, *Slovník metod* (Prague: Gallery Praha, 1999), p. 32; French edition: *Dictionnaire des méthodes* (Paris: Edition Revue K, 1991).

8. Claude Lévi-Strauss, *Triste Tropiques*, (Paris, 1955), translated into Czech as *Smutné tropy* by J. Pechar and A. Kratochvilova (Prague: Odeon, 1966), p. 211.

9. Kolář, *Slovník metod.*

10. Kolář's last collection of poems, "Návody k upotřebení" (Instructions for Use: Poems from the 1950s and 1960s) (Prague: Návody k upotrbení, 1969).

11. The most important published source of information to date on the Gorgona group and their work is the catalogue of the exhibition in the Muzej suvremene umjetnosti, Zagreb, 1990, with an essay by Branka Stipančić.

12. Ibid.

13. Ibid.

14. Pierre Restany, "Bratislava, une leçon de la relativité," *Domus* 472, no. 3 (1969), p. 49.

15. Karel Malich, interview in *Literární noviny* no. 78 (1968), p. 19.

16. Krasiński, quoted in Adam Szymcyzk, "The Thin Blue Line," in *Edward Krasiński* exh. cat. (Basel: Kunsthalle Basel, 1996).

17. Piotr Piotrowski, "Künstler und Geschichte: Über die Grenzen der Polnischen Gegenwartskunst," in *Der Riss im Raum: Positionen der Kunst seit 1945 in Deutschland, Polen, der Slowakei und Tschechien*, exh. cat. (Berlin: Martin-Gropius-Bau, 1995), pp. 63–64.

18. Slavoj Zizek, "Attempts to Escape the Logic of Capitalism," in *London Review of Books* 21, no. 21, October 28, 1999, pp. 3–7.

Jiří Ševčík is a professor of philosophy at the Academy of Fine Arts, Prague. From 1962 to 1964, he was the editor of the periodical Architektura CSSR and, until 1989, a member of the faculty of architecture at the Academy in Prague. From 1993 to 1995, he was director of the Modern Collection at the National Gallery in Prague. *Jana Ševčíková* is a free-lance art critic and, since 1990, a member of the philosophy faculty at the Academy of Fine Arts in Prague. Since the 1970s, she and Jiří Ševčík have collaborated on many international exhibitions presented at such institutions as the Museum Moderner Kunst Stiftung Ludwig, Vienna; the Musée d'Art Moderne de la Ville de Paris; and the Neuer Berliner Kunstverein, as well as the National Gallery in Prague.

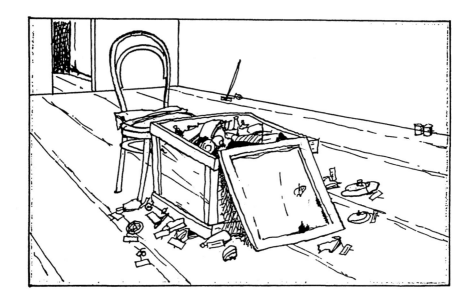

16. **ILYA KABAKOV** *STUDY FOR BOX WITH GARBAGE*, 1972
INK ON PAPER

"ПО ВОСКРЕСЕНЬЯМ" В ВОЗДУХЕ ОСО-
БЕННО МНОГОЛЮДНО, ТЕСНО, ПДАЖЕ СУ-
ЕТЛИВО ОТ БЕСЧИСЛЕННЫХ ПОДАРКОВ
И ПОКУПОК, "ЛЕТНЫХ В РАЗНОМ НАПО-
РАВЛЕНИИ, СПЕШАЩИХ ЗА ГОРОД, "БЕ-
СЕДУЮЩИХ, И ПРОСТО ЖЕЛАЮЩИХ,
КАК ГОВОРИТСЯ, НА ДРУГИХ ПОС-
МОТРЕТЬ И СЕБЯ ПОКАЗАТЬ.

НЕКОТОРЫЕ "РАДИ ШУТКИ" ГУ-
ЛЯЮТ СРЕДИ ДЕРЕВЬЕВ, ИЛИ ПРЯЧУТ-
СЯ В ГУСТЫХ ЗАРОСЛЯХ КУСТОВ.

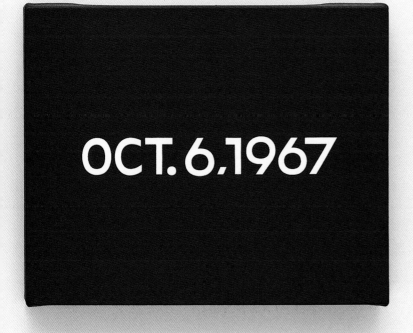

18. **ON KAWARA** *OCT. 6, 1967*, 1967
CARDBOARD BOX AND NEWSPAPER CLIPPINGS, AND ACRYLIC ON CANVAS

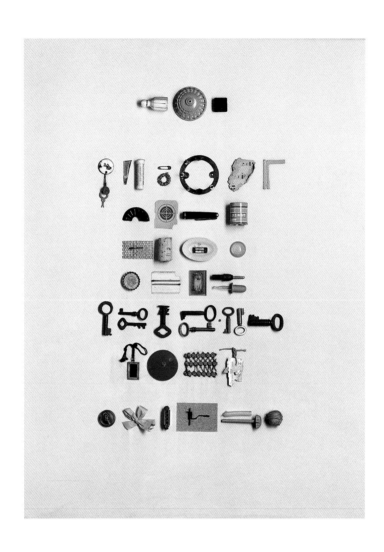

19. **JIŘÍ KOLÁŘ** *BLACK SUGAR*, 1963
ASSEMBLAGE ON BOARD

20. **JIŘÍ KOLÁŘ** *JOURNEY TO THE CENTER OF THE EARTH*, 1966
CHIASMAGE ON BOARD

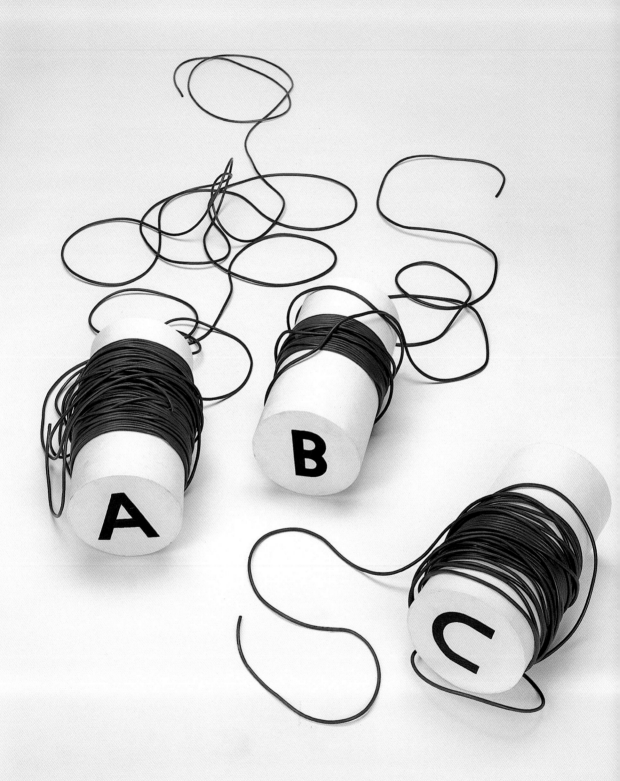

21. **EDWARD KRASIŃSKI** *ABC*, 1970
THREE WOODEN ROLLERS, ACRYLIC, AND PLASTIC CABLES

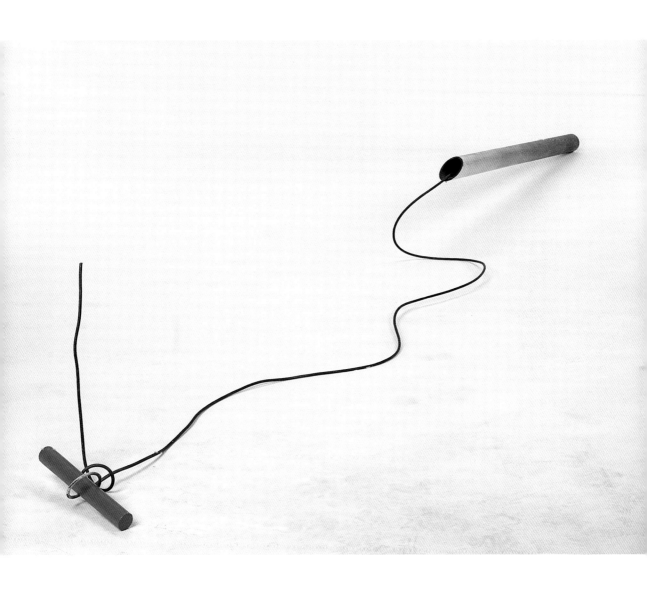

22. **EDWARD KRASIŃSKI** *H6*, 1968
IRON PIPE, STEEL WIRE, AND WOODEN ROLLER

ZERO
AND
DIFFERENCE:
EXCAVATING
A CONCEPTUAL
ARCHITECTURE

PAULO
HERKENHOFF

"We are no longer operating within the parameters of the so-called modern art. I suggest we use the expression 'post-modern art' to signify the difference." So wrote Brazilian art critic Mário Pedrosa in Rio de Janeiro in 1966.[1] Precociously coining the term "post-modernity," Pedrosa was early to argue that even while modern art was "an original, unprecedented cultural experience sprung from a deliberate isolation, so to speak, of intrinsic elements of artistic occurrences," this experience had seemingly "been consummated." Pedrosa's thinking finds parallels in Milena Kalinovska's exhibition *Beyond Preconceptions: The Sixties Experiment*; both map the Western art of the 1960s in order to understand aesthetic experiments of the period that led to a new ground—a zero degree—for an artistic language beyond the modernist tradition.

For Pedrosa, the dissolution of the modernist notion of the art object found Brazilian landmarks as early as 1959,[2] in Lygia Clark's first *Bichos* (Animals; see plate 7) and art critic Ferreira Gullar's 1959 essay "Teoria do Não Objeto" (Theory of the Non-Object). For Gullar, "The non-object is not an anti-object but a special object destined to hold a synthesis of sensory and mental experiments: a body entirely permeable to phenomenological knowledge, a totally discernible body that exposes itself thoroughly to perception."[3] By exposing Concretism, a prevailing movement in Brazilian art of the early 1950s, to confrontations with a range of different facts, theories, and cultural strategies, Pedrosa and Gullar provided the conceptual backing not only for that zero degree of artistic language but also for a construction of difference and relations of otherness through art.

For Pedrosa, those outside facts and theories embraced the fields of political science, economy, art history, psychology, philosophy, and phenomenology. Back in 1949, he had observed that art and psychology eliminated "this growing separation between modern science and the routine way of thinking and feeling of present-day man."[4] Like Kalinovska in *Beyond Preconceptions*, Pedrosa opposed the

historical conditions of creative work in advanced capitalist economies to those of third-world "pre-capitalist" countries and also to those of the Soviet economic system. These are the dissimilar bases from which the artists represented in Kalinovska's exhibition have experimented, a variety for which Mangelos's *Energy*, 1978 (plate 33), stands as a symbol. Pedrosa reviewed artistic output in the context of mass production, calling attention to the way the artist's work was conditioned by monopolist capitalism. To him, the artist under capitalism was a "positive hero"— something like a makeshift Hollywood movie actor, and a counterpart to the decadence that Stalinism ushered in under labels such as "Fine Arts for the Soviet High Bureaucracy."[5] In the mid-1960s, an effervescent period in Brazilian art, Pedrosa found it pertinent to quote Leon Trotsky, whose vision he thought illuminated a chasm in the economy and culture of that historical period in the capitalism of the nations on the so-called margins. Following Trotsky, he idealistically hoped for a fulfillment of the socialist promise in a way that would include a "time of fusion between Art and life, that is to say, a time when life will have reached those dimensions when it shall be made up entirely by Art."[6] Discussing art in relation to the material conditions of social organization, Trotsky had stated, "The effort to set art free from life, to declare it a craft sufficient unto itself, devitalizes and kills art."[7]

Beginning in the 1940s, Pedrosa was interested in the meeting of art and psychology. He explored the subject widely, reading Sigmund Freud, André Breton, Roger Fry, Rudolf Arnheim, and Franz Prinzhorn, among others,[8] and looking at the visual production of psychiatric inmates enrolled in an art-therapy experiment conducted by the Jungian psychoanalyst Nise da Silveira at a Rio de Janeiro hospital. Among Silveira's instructors were the city's early geometrist artists, including Ivan Serpa, who later taught Hélio Oiticica. The early juxtaposition of geometry and madness would provide the future basis for the antirationalist friction within Brazilian Neo-Concretist art. The idea of healing would also lie behind Clark's therapeutic "relational objects," which, however, were less metaphysical in intention than Joseph Beuys's shamanism.

Pedrosa was interested not only in visual experience but in the plurality of the human senses, and he believed that "every human being is a source of preconceived ideas, concepts, images, and beliefs."[9] His discussions of Gestalt theory

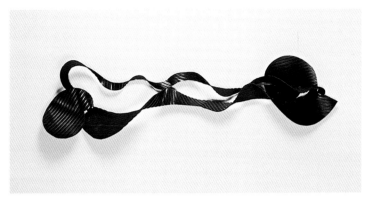

FIG. 7. **LYGIA CLARK**
RUBBER GRUB, 1964
BLACK RUBBER

and the human senses converged in Gullar's "Teoria do Não Objeto," which argued, "Everyone knows that no human experience is limited to one of the five human senses, given that the individual responds in his/her entirety."[10] In Neo-Concrete art, a phenomenology derived from Ernst Cassirer, Maurice Merleau-Ponty, and Susanne Langer ratifies art's existential meaning and restores subjective presence to art. (Concretist art had been extremely objective in structure.) Whereas the sensorial plurality (let us call this "infrasensoriality") and phantasmatic imagery of works of Clark's such as *The I and the You: Cloth-Body-Cloth Series*, 1967 (plate 5), addressed the interiority of the experiencing subject, Oiticica's work assigns a "suprasensoriality" to the social and cultural sphere. His *Parangolés* (Capes), 1965–67 (plates 43 and 44), for example, specially structured capes with objects and messages, are to be worn in dancing the samba.

Pedrosa was the leading postwar Latin American art critic, who understood Western art history not as a succession of movements or images to follow or copy but as a legacy of unresolved visual issues, and therefore also as a field for the possible, original invention of artistic language. He saw notions of "style" as models to be continuously replaced.[11] The work of Clark and Oiticica likewise activated problems inherited from Piet Mondrian, Kazimir Malevich, Josef Albers, and Max Bill. At the same time, Neo-Concretism rejected the objectivity of Concrete art and set out to reinstate subjective experience, particularly by engaging its viewers as the subjects of action and desire. According to Gullar's "NeoConcrete Manifesto" (1959), "NeoConcrete art, born out of the need to express the complex reality of modern humanity inside the structural language of the new plasticity, denies the validity of scientific and positivist attitudes in art and raises the question of expression."[12] The manifesto further states that in the language of art, the concepts of form, space, time, and structure are bound to existential, emotional, and affective meanings. Thus Clark's *Bichos* (see *Bicho*, 1966 [plate 7]), a structure of metal planes to be activated by the

public, set forth an experimental process with space-time as the "foundation of a new expressive space." The fact that the experimental time of Oiticica's *Parangolés* and Clark's *Caminhando* (Walking), 1964, a work involving cutting longitudinally through a Möbius strip, is nontransferable among individuals evokes Pedrosa's phenomenology of the senses, and his interpretation of the emerging art as no longer following the modernist canon. The work of Clark and Oiticica involves odors, sounds, and touch. Clark wrote to Oiticica, "I'm working on a series of sensorial masks that closely resemble your *Parangolé*. They are immense pieces; to look inside them is to bend over a true abyss!... When filling up plastic bags with air, one has the impression of molding oneself in this space; this experience leads to a perception that transcends the space taken up by one's own body."[13] There is no border between the inner dimensions of the phantasmatic images of Clark's collective body, or between the socially marginal
and transgressive Dionysian spaces favored by Oiticica, such as Brazil's *favelas* (slums) and its carnival festivities, whose costumes inspired the *Parangolés*.

The art and theory of Neo-Concretism brought the articulation of the senses, as well as altered notions of the art object and of symbolic space, to ensuing generations of Brazilian artists such as Anna Maria Maiolino and Cildo Meireles. In 1964, a military dictatorship seized power in the country, and this national trauma led artists to incorporate political strategies in their work. Maiolino's drawings and artist's books contain topographically indefinite spaces (see plates 27 to 30)—spaces of grief and imprisonment resulting from a gravitational collapse of language. The political and metaphorical meanings of the work are clear. Maiolino's practice of drawing lines with string, making space cohesive, points to a possible dialogue

with Karel Malich. In *Black Hole*, 1974 (fig. 8), and in the installation *Entrevidas*, 1981, Maiolino renders political tragedy by contriving sensory experiences infused with military symbolism. Entrevidas is an irregular space filled with hundreds of eggs; to cross it is to experience a mounting tension with each footstep. As in a minefield, advancing and returning become equivalent—neither is safer than the other. The place created by *Black Hole* and *Entrevidas* lies somewhere between the preverbal stage (the works are metaphors for the life before birth) and the nonverbal stage (in which the strangeness of the environment arouses a growing fear). In the dark of the *Black Hole*, the gaze focuses on the void and the unutterable.

Coming in the wake of Gullar's "Teoria do Não Objeto," Meireles's objects and installations rub Western rationalism against perverse or poetic Brazilian social issues. Meireles confronts both the excessive and the essential: *Mission/Missions*, 1987, is a collection of 600,000 coins; *Southern Cross*, 1969–70 (plate 38), involves a tiny cube of pine and oak, the sacred trees that Brazilian Indians use to acquire knowledge of fire. Meireles works against the idea of history as an achievement of European civilization. His *Insertions into Ideological Circuits*, an ongoing series begun in 1974, are guerrilla appropriations of mercantile circulat-ory systems—for example, inscriptions added to Coca-Cola bottles before they are placed back in circulation (see *Insertions into Ideological Circuits: Coca Cola Project*, 1970 [plate 40]). For Meireles, "*Insertions* are not industrialized objects introduced in the realm of art, but the work of art that doubles as an industrialized object."[14] His paradigms are Gullar's "non-objects," Marcel Duchamp's readymades, and the work of Oiticica. According to its label, his *Money Tree*, 1969 (plate 39), contains 100 one-cruzeiro bills yet is worth 2,000 cruzeiros. Revealing the value added by the artist's labor, the label provokes the viewing public; in exposing the imaginary constitution of the object as exchange value, Meireles also takes apart the monetary illusion of use value, in a veiled exploration of the politics of work. When military repression was at its height, he produced *Tiradentes: Totem-Monument to the Political Prisoner*, 1970 (figs. 10a and 10b), in which live chickens were tied to a pole, gasoline was poured on them, and they were set on fire. Tiradentes was a martyr in Brazil's struggle for independence; the name invokes an imaginary ideal of freedom, and in applying it to this totemic sacrifice Meireles was suggesting the voice of a political prisoner tortured in solitary confinement. Making visible what history hides,

FIGS. 9A AND 9B. **ANNA MARIA MAIOLINO** *IN/OUT (ANTHROPOPHAGY)*, 1973 (VIDEO STILLS)
VIDEOTAPE

Meireles was echoing an idea of Pedrosa's—that art is the experimental exercise
of freedom.

Neo-Concretism succeeded in creating an autonomous artistic language.
Similarly, the symbolism of cannibalism in European art, outlined by Francis Picabia,
was assimilated in 1928 in Brazil by painter Tarsila do Amaral and poet Oswald
de Andrade to create the Brazilian *Antropofágia* ("Anthropophagy") movement as
a strategy for autonomous expression. In the discourse of *Antropofágia*—literally,
"cannibalism"—elements from foreign cultures were to be incorporated and
converted into an original and independent language. Similar ideas have been
articulated by Clark (in works such as *Baba Anthropofágica*), Oiticica (in his *Tropicália*),
Maiolino (in her *IN/OUT [Anthropophagia]*, 1973 [figs. 9a and 9b]), Meireles' (in his
Tiradentes, 1970 [figs. 10a and 10b]) and in various works by Victor Grippo, Eva Hesse,
and Bruce Nauman.

In Dante's *Inferno* and Géricault's *Raft of the Medusa*, cannibalism is symbolic
hunger; in Yves Klein's *Grande Anthropophagy Bleue—Hommage à Tennessee Williams*
(a reference to Williams's play *Suddenly Last Summer*), it is violence. In Grippo's *The
Artist's Meal*, 1991, man devours earth. In Maiolino's *IN/OUT (Anthropophagia)* silences,
shapeless sounds, and essential discourse exacerbate the condition of speech under
censorship. Nauman's *Anthrosocio*, 1991, remarks on human nature by making
a pair of ceaseless claims: "Help me! Hurt me! Sociology" and "Feed Me! Eat Me!
Anthropology." This work evokes Neo-Concretist artist Lygia Pape's work *Eat Me,
Gluttony or Lust*, 1975. In Clark's *Caminhando* the gesture of cutting through the Möbius
strip offers the experience of immanent time on a topological structure; this kind
of reconversion of meaning out of a simple gesture also appears in Hesse's art. Mary
Jane Jacob has applied the concepts of chaos and contention to works of Hesse's such
as *Accession*, 1967, and also to some of Robert Smithson's, discussing both artists in

relation to Clark (a comparison that could be extended to Oiticica).[15] *Anthropophagy* is the reconversion of symbolic energy while Smithson's *Non-Sites* deal with the dispersion of energy, with entropy. "Art," Pedrosa argued, "is the only thing that is against the entropy of the world."[16]

Beginning in the 1940s, aesthetic exchange had intensified between Brazil and Argentina, with artists, critics, the Communist Party, the *Bienal de São Paulo*, and the Museu de Arte Moderna in Rio de Janeiro all playing a role. In the 1960s, while Brazilian Neo-Concretists were developing a phenomenological approach, Argentinians were more concerned with discussions about art and systems of communication, Marshall MacLuhan being a major reference. Grippo constructed a poetic epistemology through the application of conscience to science, combining natural science and the physical organization of production. A chemist fascinated by alchemy, Grippo imparts social meaning to the metabolic process of the potato;

FIGS. 10A AND 10B. **CILDO MEIRELES**
TIRADENTER: TOTEM-MONUMENT TO THE POLITICAL PRISONER, 1970 (DETAIL)
BLACK-AND-WHITE PHOTOGRAPHS

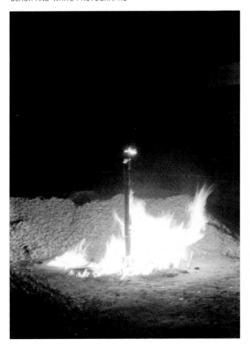
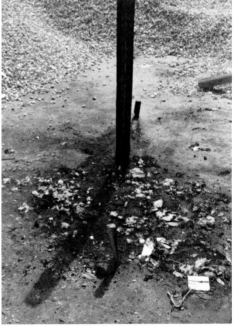

FIG. 11. **VICTOR GRIPPO** *SYNTHESIS*, 1972
POTATO AND CHARCOAL

there is a dialogue here—in works such as *Synthesis*, 1972 (fig. 11)—with Beuys's symbolic use of energy. Similarly, the lead rose in Grippo's *Igne*, 1979 (plate 13), is juxtaposed with the burned twigs of a rose bush, highlighted in gold. Materially, Grippo's production rests on a combination of instruments of labor, forms of knowledge, and nutrition. "Labor and nature are sources of use value," Marx states in *Critique of the Gotha Program*, stressing that "the emancipation of labor demands the promotion of the instruments of labor to the common property of society."[17] In *Tables for Work and Thought*, 1978, Grippo combines labor, thought, emotion, food, art, and metaphysical intention.[18] In *A Few Trades*, 1976, he brings together art and labor, viewing humanity's dialogue with and use of tools as a human ritual endowing Hegel's *Homo faber* with Gaston Bachelard's "volonté matérique" (will to substance) in the process of dominat-ing and changing nature.

To Brazilian poet Haroldo de Campos, "difference" is fundamental to auto-nomous artistic creation.[19] Discussing the genesis of "post-modernism," Pedrosa remarked in 1966, "Western artists strived to survive without pre-established standards, self-supportively and on their own, sucking inspiration from alien cultural sources for the sake of the absolute in visual values, regardless of original cultural standards. . . . Consciously or unconsciously, they begin to propose other things, particularly a new attitude whose more in-depth meaning they are not fully aware of as yet."[20] It was this kind of knowledge of a zero degree that Kasimir Malevich described in his essay "The Suprematist Mirror." The political project of *Beyond Preconceptions: The Sixties Experiment* involves mapping the zero degree of art and difference in a horizon shared by artists all over the world, thus superseding the plays of imperialist subordination.

1. Mário Pedrosa, "Crise do Condicionamento Artístico," *Correio da Manhã* (Rio de Janeiro), July 31, 1966. The quoted passage was translated from the Portugese by Izabel Murat Burbridge.

2. Mário Pedrosa in *Correio da Manhã* (Rio de Janeiro), June 18, 1967.

3. Ferreira Gullar, "Teoria do Não Objeto," *Jornal do Brasil* (Rio de Janeiro), December 19, 1959.

4. Mário Pedrosa, "A Arte e as Linguagens da Realidade," *Inaugurando* (Rio de Janeiro), 1949.

5. Mário Pedrosa, "Vicissitudes do artista soviético," *Correio da Manhã* (Rio de Janeiro), August 28, 1966.

6. Ibid.

7. Leon Trotsky, "The Social Roots and the Social Function of Literature," 1923, in *The Collected Writings of Leon Trotsky: Trotsky Internet Archive* [at www.marxists.org].

8. Mário Pedrosa, "Pintores de Arte Virgem" (1950) and "Forma e Personalidade" (1951), in *Dimensões da Arte* (Rio de Janeiro, 1964), pp. 105 and 61, respectively.

9. Mário Pedrosa, "A Arte e as Linguagens da Realidade."

10. Ferreira Gullar, "Teoria do Não Objeto."

11. Mário Pedrosa, "Crise do Condicionamento Artístico."

12. Ferreria Gullar, "Neoconcrete Manifesto," quoted in English in Dawn Ades, *Art in Latin America* (New Haven: Yale University Press, 1989), p. 336. First published in *Jornal do Brasil* (Rio de Janeiro), March 22, 1959.

13. Lygia Clark, letter to Hélio Oiticica, November 14, 1968. In Luciano Figueiredo, ed., *Lygia Clark e Hélio Oiticica: Cartas, 1964–1974* (Rio de Janeiro: UFRJ, 1996).

14. Cildo Meireles, interview with Nuria Enguita, in *Cildo Meireles* (Valencia: Instituto Valenciano de Arte Moderno, 1995).

15. Mary Jane Jacob, "Containment and Chaos: Eva Hesse and Robert Smithson," in *XXIV Bienal de São Paulo. Núcleo Histórico: Anthropophagia e Histórias de Canibalismos* (São Paulo: Fundação Bienal de São Paulo, 1998), pp. 478–85.

16. Mário Pedrosa, interview with Antonio Manuel, May, 1970. In *Homenagem a Mario Pedrosa* (Rio de Janeiro: Museu de Arte Moderna, 1984).

17. Karl Marx, "Critique of the Gotha Program," 1875, in *The Marx-Engels Reader*, ed. Robert C. Tucker (New York: W.W. Norton & Co., 1978), pp. 525–27.

18. See Catherine de Zegher and Elizabeth A. MacGregor, eds., *Victor Grippo* (Birmingham, England: Ikon Gallery, 1995), p. 53.

19. Haroldo de Campos, "Da razão anthropophágica: diálogo e diferença na cultura brasileira" (1980), in de Campos, *Metalinguagem & Outras Metas* (São Paulo: Perspectiva, 1992), p. 246.

20. Pedrosa, "Crise do Condicionamento Artístico."

An adjunct curator of contemporary art at the Museum of Modern Art, New York, *Paulo Herkenhoff* was the artistic director of the *XXIV São Paulo Bienal*. He has curated many other international exhibitions such as *Deconstructing the Opacities of History (Encounters/Displacements)* at Texas University, Austin (1992), has appeared on numerous panels, and published extensively.

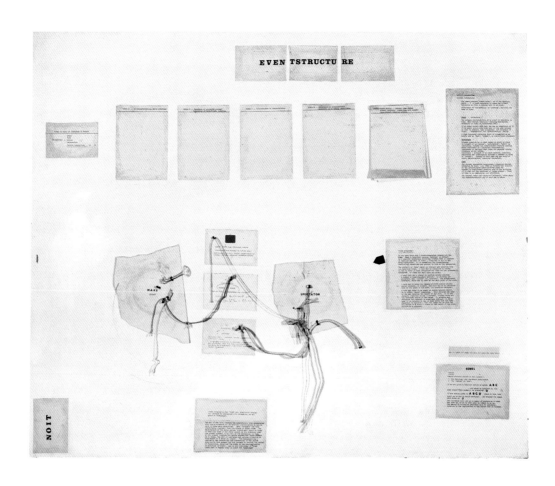

23. **JOHN LATHAM** *EVEN TSTRUCTU RE*, 1966–67
PAPER, STAPLES, CARDS, STRING, AND PAINT ON HARDBOARD

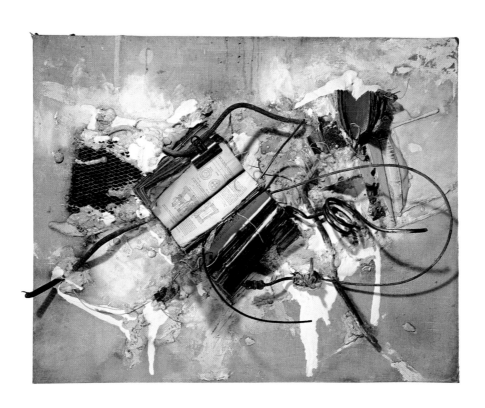

24. **JOHN LATHAM** *PHILOSOPHY AND THE PRACTICE OF*, 1960
SIGNED AND PAINTED BOOKS, MIXED MEDIA, AND PLASTER ON CANVAS ON HARDBOARD

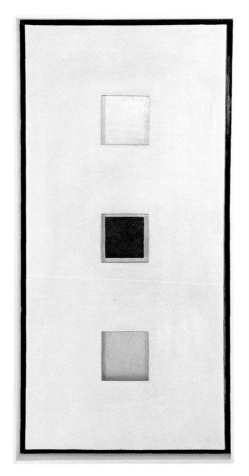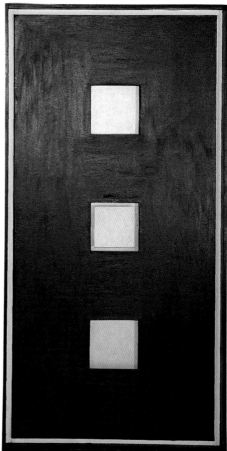

25. **SOL LEWITT** *DOUBLE WALL PIECE*, 1962
OIL ON CANVAS AND PAINTED WOOD

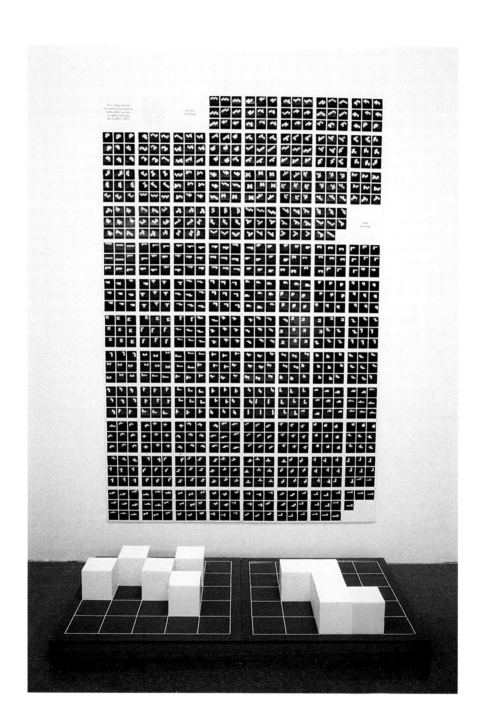

26. **SOL LEWITT** *FIVE CUBES ON TWENTY-FIVE SQUARES*, 1977
PLASTIC AND WOOD

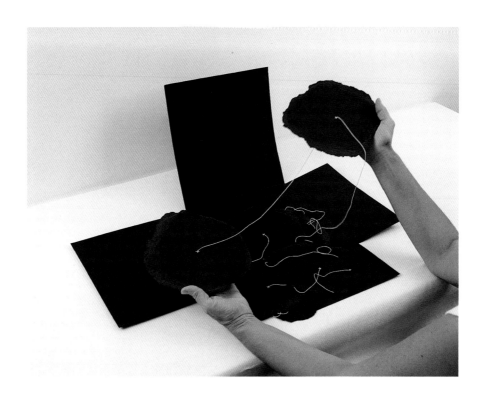

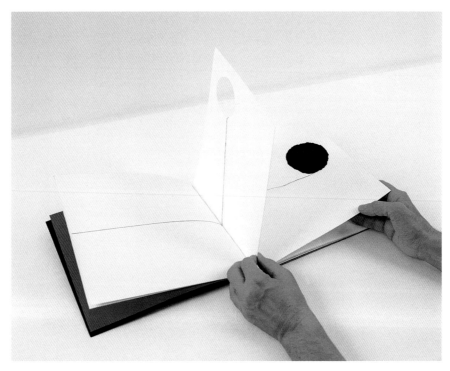

ANNA MARIA MAIOLINO
27. (TOP) *ON THE LINE*, 1976
BOOK OBJECT: BLACK PAPER (MURILLO) AND THREAD
28. (BOTTOM) *TRAJECTORY I*, 1976
BOOK OBJECT: PAPER (MURILLO), ACRYLIC INK, AND THREAD

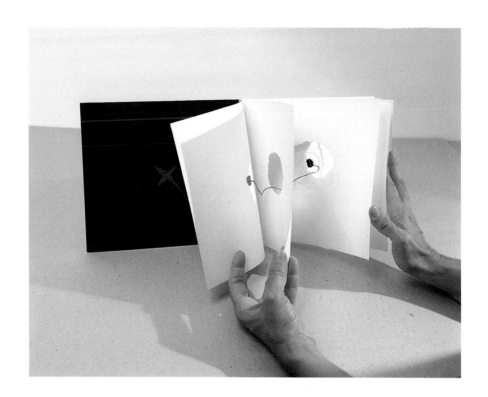

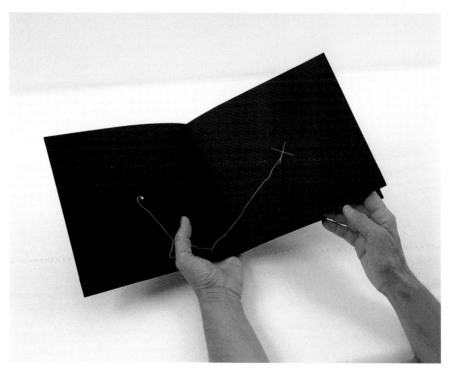

ANNA MARIA MAIOLINO
29. (TOP) *POINT TO POINT*, 1976
BOOK OBJECT: PAPER (MURILLO) AND THREAD
30. (BOTTOM) *TRAJECTORY II*, 1976
BOOK OBJECT: BLACK PAPER (MURILLO) AND THREAD

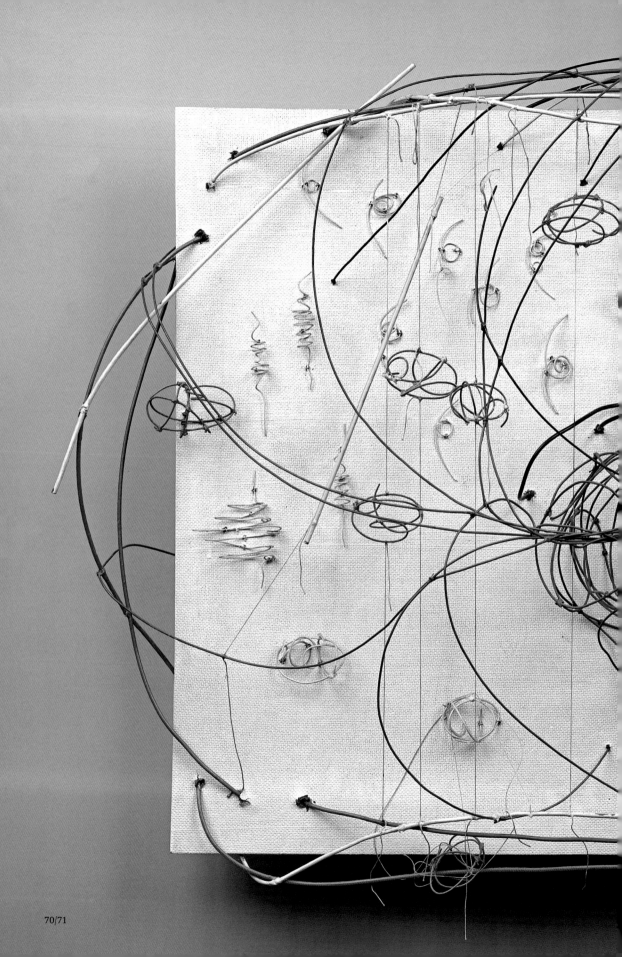

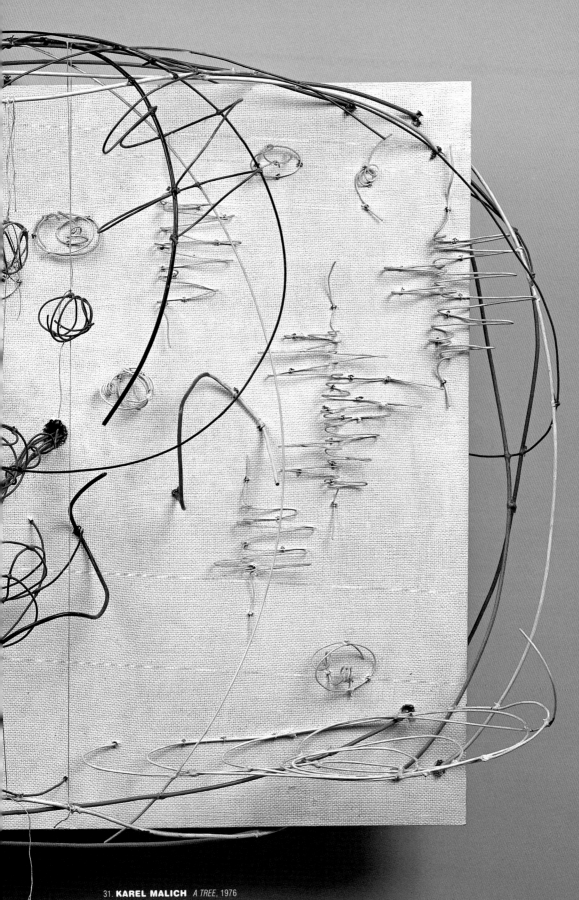

31. **KAREL MALICH** *A TREE*, 1976
MASONITE, WIRE, STRING, AND PAINT

THE
MATERIAL
TURN
IN THE
ART OF
WESTERN EUROPE
AND
NORTH AMERICA
IN THE
1960S

MICHAEL
NEWMAN

The art of the 1960s and 1970s took up once again the experimental approach of the first decades of the century that had called into question traditional conceptions of the status of the object—whether we understand those conceptions in terms of the substantial basis of the things represented or in terms of the medium as the sensuous embodiment of an idea. The break with the traditional opposition of matter and form led not—as many, including some of the artists themselves, thought—to a "dematerialization" of art, or to the abandonment of product for idea, but rather to various displacements and rethinkings of materiality itself. Indeed, one of the aims of this "dematerialization," which was articulated in the context of the utopian political activism of the 1960s, was to free art from the fetishization of the hand-made object in late modernism, and to engage its materiality as action, event, language, and mechanical reproduction.

How exactly was this understanding and experience of materiality transformed during the 1960s and early 1970s? The turn to language in Conceptual art has generally been understood as a shift of emphasis from object to idea. However, in retrospect—especially given the emphasis on the body in much post-Conceptual art—this move can be seen more accurately as an attempt to free materiality from an "objecthood" that has become aesthetically and politically compromised. "I think that I am really just a materialist," Lawrence Weiner has said, explicitly refuting the notion that the turn to language involves the substitution of the ideal for the material.[1] Language appears to function in Weiner's work primarily as a descriptive proposition: "I'm trying to use language as a means of presenting a mise-en-scène, a physical reality," he has stated.[2] However, as in his book STATEMENTS (1968), description precedes and does not necessarily imply the fabrication of the object.

FIG. 12. **LAWRENCE WEINER**
A SQUARE REMOVAL FROM A RUG IN USE, 1969
LANGUAGE + THE MATERIALS REFERRED TO

Historically, Weiner's work may be seen as a response to the Minimalist fetishizing of serial, industrial production. What is distinct about Weiner's materialism is his extension of the tendency of Minimalism to draw its context into the experience of the work in order to de-fetishize the object. He does so first by rendering the object negative (for example, by having a piece of rug cut out of a carpet that is already installed, as in *A Square Removal from a Rug in Use*, 1969 [fig. 12], rather than adding another object to the world), then by focusing attention on the site as a space of inscription and circulation. Weiner has referred to his interest in how the "context itself becomes as much a part of the work as the work itself" and in "the movement of work (information) from one context to another,"[3] and his installations generally highlight the characteristics of the spaces for art—including exhibition catalogue, gallery, wall, and poster—by emphasizing the differences between them, as in *FIRE-CRACKER RESIDUE OF EXPLOSIONS AT EACH CORNER OF THE EXHIBITION AREA*, 1969.

Sol LeWitt's "Paragraphs on Conceptual Art" from 1967 was an influential source of the "dematerialization" thesis. The essay implies a shift of emphasis in Conceptual art from the materiality of the object—still present in early works such as *Double Wall Piece*, 1962 (plate 25), or even *Wooden Piece*, 1964—to the idea that it is supposed to convey. However, in LeWitt's later work, materiality is displaced rather than suppressed: it is no longer conceived in relation to the thing as "stuff," but as the outcome of a process where—through the repetition of similar units within all possible permutations of a structure—minimal difference has been introduced, resulting in repetition that is excessive rather than rationalist. This is, for instance, the case in his book of offset prints *Four Basic Kinds of Line and Colour,* from 1972. The fact that, in his wall drawings, the artist's contribution shifts from realization to instruction also implies the displacement rather than the suppression of

materiality. Here, materiality does not precede the act, but results from the elaboration of a rule, the outcome of which exceeds any possible prescription. This process is equally true in LeWitt's three-dimensional structures, such as *Five Cubes on Twenty-five Squares*, 1977 (plate 26), where the "rule" generating them cannot determine the way in which they will be experienced.

The idea of a work of art as the elaboration of a function or rule also governs Hanne Darboven's approach, only she presents herself as the functionary of a law given by the way time is distributed. In her work, the numerical version of the calendrical date is material for a sum, and writing becomes the cursive gesture typical of rote-learning. Recording time and writing are assumed as tasks (adding, filling lines) followed through to the end; in *Untitled, 1.1.74–31.1.94*, 1974–94 (plate 8), the end is the last day of the month of January. If time is traditionally the medium whereby what is "outside" is internalized by consciousness, Darboven seems to reduce time itself to the exteriority of calculation and writing practice. In these pieces—including *Merry Is the Gypsy's Life*, 1979 (plate 9), titled after a popular German folk tune—we begin to see the sense of senselessness, the emptying out that results from the repetitive strategies of making. Darboven's more recent work combines a Minimalist use of repetition (learned during a formative period in New York, when she was close to Sol LeWitt) with a sense of the relation of such repetitive strategies to historical trauma. *Kulturgeschichte 1880–1983*, 1980–83, for instance, presents covers of the periodical *Der Spiegel* that deal with representations of the Holocaust.

History is also at issue in the work of On Kawara. Kawara places each of his "Date Paintings"—which feature only the month, day and year on which he paints it, in large letters and numbers on a monochrome ground—in a box with a newspaper or section of newspaper of the day and country where the painting was made. The *New York Times* in the box for *Oct. 6, 1967*, 1967 (plate 18), has a picture of three G.I.'s with a wounded comrade they have tried in vain to save, with the caption "Killed in Action: Three Faces Reflect the Grim Statistics of a War." Photojournalism presupposes a representability that the monochrome ground of this date painting denies. Here, painting is understood as a crisis—induced by photojournalism—of the relation between the monochrome and history painting. That crisis is enacted as a split between the painting and its container. At stake here is the relation of painting

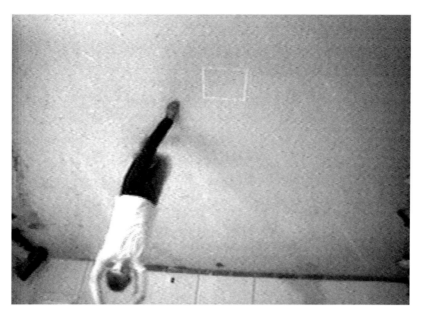

FIG. 13. **BRUCE NAUMAN** *PACING UPSIDE DOWN*, 1969 (VIDEO STILL)
VIDEOTAPE

as event in modernism to the way technology and culture mediate historical events. With his postcards and telegrams, Kawara also participates in Conceptual art's use of various conventional "non-art" means of communication and circulation—its recognition of these forms as integral to rather than external to the work. Kawara's work looks forward to the post-modern moment when geography—crossing borders, diaspora, wandering—is freed from an understanding of history as proceeding in a linear direction toward a goal. In Kawara's approach, individuality is emptied of Romantic interiority and becomes the non-transcendent point where the subject, rather than internalizing and transcending the world, is exposed to it.[4]

During the 1960s, there was also a shift of emphasis in art from object to event, which in turn implies a rethinking of time. Particularly in art using performance, film, and video, time is reconceived as a medium in itself, rather than simply as a passage from one privileged moment to another. We see precisely this rethinking of the temporal role of movement without goal in Bruce Nauman's performance-videos. In *Pacing Upside Down*, 1969 (fig. 13), Nauman (through the inversion of the camera) appears to be walking on the ceiling in a series of circles, the diameter of which increases until he is outside the range of the camera. A device to which Nauman continuously has recourse is difference-within-repetition, as in *Studies for Holograms*, 1970 (plate 41). The works are repetitive enough for the difference of each individual "beat" to be discernible (if sometimes with a degree of uncertainty on the

part of the viewer). At the same time, they are different enough for the repetition not to sink into homeostasis, although this remains an ever-present possibility.

Eva Hesse takes certain aspects of Minimalism—horizontality, literalness, repetition, and exclusion (or hollowing out) of a center—and diverts them toward a more explicit relation with the *informe* in a way that either changes how they function or at least performs a displacement. In doing so, she renders problematic any opposition of form and formlessness. The rectilinearity of the Minimalist unit comes to be related to a bodily part-object: wire is bandaged, hard metal structures are replaced by latex and resin, the shine of industrial finish or the resistance of surfaces give way to transparency and internal glow, durability to fragility and decay (see *Model for Accretion*, 1967 [plate 14]). Yet it would be misleading to refer to her process in terms of the horrifying collapse of the space between subject and object, insofar as Hesse's work retains a structure that keeps such a collapse at bay. In part, it does so through the use of the repetition both of distinct units and the processes of making, and in

FIG. 14. **EVA HESSE** *UNTITLED*, 1965
INK, GOUACHE, AND WATERCOLOR ON PAPER

FIG. 15. **JOSEPH BEUYS** *FINGERNAIL IMPRESSION IN HARDENED BUTTER,* 1971
BUTTER, WAX, PLASTIC BOX, AND GRAY CARDBOARD

part through the maintenance of a pictorial and imaginary space, as evident in her
drawings from the mid-1960s (see *Untitled,* 1965 [fig. 14]). In Hesse's work, form (as
structure) is not opposed to materiality, but is itself a material element, such that
there is a tension within materiality itself, evident, for instance, in her "Test Pieces"
series from 1966–69 (see plate 15). If it is the case that Hesse not only subjectivizes
but also genders the supposedly "universalist" materiality of Minimalism, this
would need to be explored not in terms of a simple opposition of masculinity and
the femininity, but rather in terms of bisexuality, involving not structure in op-
position to formlessness but the interplay of different, equally material modes of
structuring and de-structuring.

No longer primary matter waiting to be stamped or shaped by form,
materiality comes to be associated with a "remains" not assimilable to, or left behind
by, this process.[5] Joseph Beuys's work consists of "remains" in two senses that cancel
each other out: the remains of atrocity (bodies rendered into fat, the stamp of a
Party insignia recalling Nazi documents), and the relics of the artist. (These contrary
approaches to the concept of remains are evident in *Fingernail Impression in Hardened
Butter,* 1971 [fig. 15], on the one hand, and *Felt Suit,* 1970 [plate 2], on the other.) The
danger with Beuys's work is that the former are absorbed into the latter: the remains
of atrocity, which should call into question any possibility of sublation or
sublimation, become subsumed under the most banal discourse of universal
creativity. In contrast, Betty Goodwin, working in Canada and dealing with a history
of immigration and displacement, uses the vests and tarpaulins incorporated directly
into her work to recall her father, "who had trained as a tailor in Romania, [and]
had owned and operated a small contracting firm for vest-making in Montreal."[6]
These remains are, literally, "vest-ages" (see *Crushed Vest,* 1971 [plate 10]). Clothing of

a dead loved one is the hardest thing to give away. Here the actual clothing is on the way to becoming a representation; as the tie to the dead is unpicked, like the thread of a seam, the relic-become-image replaces the lost one, thereby acknowledging his or her absence. But this replacement also means that the representation makes absent, or kills once again, as in *Tarpaulin #10 (Passage for a Tall Thin Man)*, 1974–91 (plate 11).

The use of spray painting in John Latham's book-assemblages from 1958 onward (for instance, *Philosophy and the Practice of*, 1960 [plate 24]) not only serves to unify the elements on the canvas, it also emphasizes that the work came into being through an event, but without tying that event to gesture (the pieces follow Rauschenberg's *White Paintings* of 1951, where the monochrome becomes a surface for projection).[7] Rather than serving as a subjective expression of interiority, such work becomes a performative demonstration of a metaphysical claim concerning

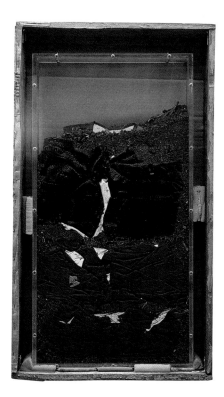

FIG. 16. **BETTY GOODWIN** *VEST EARTH*, 1974
MIXED-MEDIA ASSEMBLAGE: THREE VEST PIECES,
EARTH FROM THE GARDEN, AND WOODEN BOX

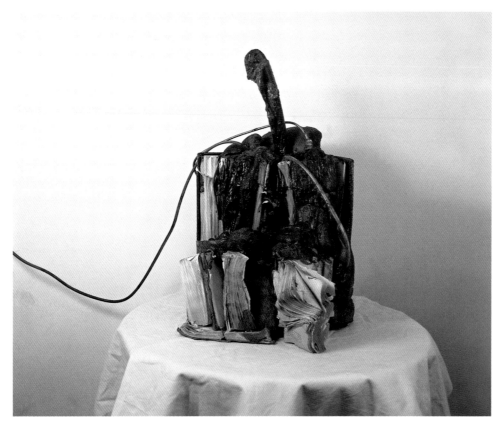

FIG. 17. **JOHN LATHAM** *FIRENZE*, 1967
POLYSTYRENE FOAM, BOOKS, PLASTIC TUBES, AND METAL PIPES

the relation of the space of objects to the time of events. The text appended to
the panel in *EVEN TSTRUCTU RE*, 1966–67 (plate 23) asserts that the primacy of the
event involves the priority of time, an idea which, like any other, itself requires space
(or spacing) for its presentation. The emphasis in Latham's artworks is on the object
as a record of a change of state, instead of on the permanent presence of the object.
As such, materiality is associated with transmutation. It is in light of this phenome-
non that Latham's *Art and Culture* (also 1966–67, and one of the emblematic works of
Conceptual art), may be seen as much more than a mischievous gesture aimed at the
imperialism of New York high modernism. For this piece, Latham invited students
to chew pages of Clement Greenberg's influential book of that title, added sulphuric
acid to the mulch, converting the cellulose into sugar, neutralized the acid with
sodium bicarbonate, then finally added yeast and allowed the mixture to ferment,
before returning it in a vial labeled "Art and Culture" to the library of Saint Martins
School of Art—from which he was then fired. This gesture—like all of Latham's
work—freed an event of transmutation from the stasis of the object (the alchemical
resonances are hard to avoid), and presented a performance-based critique of Green-
berg's modernist fetishization of the artwork as an object to be stared at and

subjected to aesthetic judgment. In a similar spirit, Latham burned an entire set of the 1964 edition of the *Encyclopedia Britannica* for his work *Skoob Tower*, 1964 (Latham's 1996 reenactment is shown in figs. 18a and 18b). The displacement of materiality from object to event implies a fundamental transformation of the artist's social role as well: with Barbara Steveni, Latham founded the Artist Placement Group (APG) in 1966 (it was renamed 0+1 in 1989). Under its aegis, artists were placed in government, industry, and media organizations with the aim not of making objects to decorate the environment, but of transforming our understanding of how artists work.

Latham's *Art and Culture* is now in the collection of the Museum of Modern Art in New York. However, in many cases new approaches to materiality coincided with what from our current perspective in the year 2000 appears to be the last efflorescence of the idea of art as "avant-garde"—a moment when the critique of society by the avant-garde also required the avant-garde to subject itself to critical scrutiny. Whereas in the U.S. and the U.K. this critique tended to assume a somewhat positivist and sociological cast, in Western Europe it involved an attack both against the heroic conception of the artist re-imported from the U.S. via Abstract Expressionism, and against the European residue of Symbolist aestheticism.

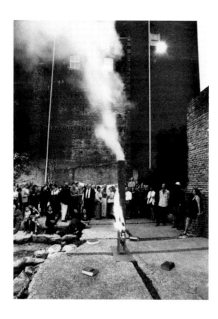

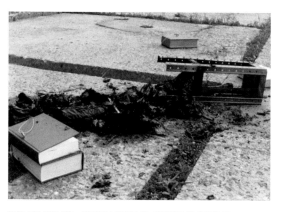

FIGS. 18A AND 18B. **JOHN LATHAM** *BURNING OF (SKOOB TOWER),* 1964
REENACTMENT AT THE MATTRESS FACTORY, PITTSBURGH, PA, MAY 31, 1996
PHOTO DOCUMENTATION OF PERFORMANCE WORK

FIG. 19. **MARCEL BROODTHAERS** *PORTE A*, 1969
ENAMEL AND PLASTIC

Italian artist Piero Manzoni's target was the use of gesture in *art informel* as a means of unifying the artist with the object—a posture that in Manzoni's view thereby gains a spurious authenticity as a form of expression. For Manzoni, the art object is no longer the expression, but rather the "vestige" of the artist. The vestige may remain linked to the artist as an indexical sign, causally related to its source: for example, the artist's own shit preserved in a sealed can, his thumbprint on an egg, or his breath captured in a balloon (see *Body of Air*, 1959–60 [plate 37]). But the vestige can also become detached from that of which it is a vestige, as in his *Achromes*, 1958–63. Most characteristically, the artist gave the creased canvas of the *Achromes* a unifying and deadening white coat of kaolin. The materials and objects that he sometimes attached to these canvases were given the same covering, or else already white materials were simply used. Manzoni's work is distinct from that of Beuys in the way he detaches vestige from relic (by incorporating elements of industrialization and commodification), and creates a parody of the notion of the artist as genius-creator. The materials of Manzoni's *Achromes* evoke both a (medical) relation to the body and an industrial context (see plate 36). The rejection of the expressive mark for the indexical one is here combined with the deadpan repetition of the commodity, including the artist's own commodified body.[8] For Manzoni, the sublimating power of art can now only be the object of parody. His work suggests

the possibility of transcendence (as a memory of the failed avant-garde in the post-war reconstruction), even as it cancels it out (by his use of serially structured ready-made materials).

It may have been an encounter with Manzoni that suggested to Marcel Broodthaers that he could turn himself from a poet into a visual artist. Manzoni showed Broodthaers how, after Duchamp and in the context of early Pop art's embrace of the image of the commodity, the value of art was attributed by means of its baptism by the artist—in other words, by the artist naming, signing, or merely selecting the work: "We met as if we were actors. This meeting with Manzoni on 25.2.62, the date of the certificate which states I am a 'work of art,' allowed me to appreciate the distance which separates the poem from a physical work which implicates the space 'fine arts.'" [9] However, in contrast to Manzoni's phantasmic, albeit parodic gestures of omnipotence, Broodthaers speaks from the distancing perspective of the artist as a role to be played, or as a signifier in a system (see the empty pedestal in *AAA Art*, 1967 [plate 3]) that had become largely economic. He rejects both gestural abstraction and the attempt by Nouveau Réalisme to incorporate reality raw by accumulating and framing found objects. In 1963, Broothaers made his first work of "fine art," *Pense-Bête* (a term meaning aide-mémoire or crib), by embedding in plaster an open package of slim volumes of his own poems, thus entombing a vestige of himself in the material associated with the death-mask and with casting traditional sculpture. In contrast to the work of other Conceptual artists, the relation of language to object is here not one of substitution but of mutual negation: the presentation of the object forecloses the possibility of reading, while removing the book would destroy the art object and therefore its value as art-commodity. [10]

Whereas Samuel Beckett served as a model for certain American artists, such as Nauman in *Slow Angle Walk (Beckett Walk)*, 1968,[11] Broodthaers could be said to be an heir of Mallarmé—but with a twist that relates sign value to economic value and ideology. The play on the relation between myth, sign value, and economic value—evident, for instance, in *The Crow and the Fox*, 1968 (fig. 22) or *ABC*, 1975 (fig. 21), is extended in Broodthaers's series of vacuum-formed plastic plaques, *Industrial Poems*, 1968–70, such as *Porte A*, 1969 (fig. 19), where words are isolated, taken out of

circulation, to assume a quasi-poetic role recalling the modernism of Mallarmé.[12] At the same time, the plastic plaques are produced using industrial means, and are therefore (in principle) reproducible ad infinitum. However, these editions are usually limited to seven. Clearly works of art in the age of mechanical reproduction, they nevertheless through scarcity lay claim to the value of art-commodities, thereby functioning as an aesthetic recuperation of the failure of the critical, political dimension of reproduction.

Broodthaers's insistence on the material signifier is part of his and others' political analysis of art itself. In the context of a political pessimism that followed the activism of 1968, in which Broodthaers participated, this work reveals art's own institutional role in negating dissent. We find in Broodthaers' work a skepticism about the ability of either theoretical reflection or aesthetic transgression to effect social change. Using myth as a model of ideology, Roland Barthes argued that "Myth can reach everything, corrupt everything, and even the very act of refusing oneself to it."[13] It does so, Barthes said, by transforming the substance of what resists it into the form of a second-order sign and thereby reintegrating it into the naturalized, mythic order. We can see how a conceptual presentation intended to deconstruct art can itself become a signifier of "art," in the same way that excessive and

1. THE ARTIST MAY CONSTRUCT THE WORK
2. THE WORK MAY BE FABRICATED
3. THE WORK NEED NOT BE BUILT

EACH BEING EQUAL AND CONSISTENT WITH THE INTENT OF THE ARTIST
THE DECISION AS TO CONDITION RESTS WITH
THE RECEIVER UPON THE OCCASION OF RECEIVERSHIP

FIG. 20. **LAWRENCE WEINER** *THE ARTIST MAY CONSTRUCT THE WORK*, 1969

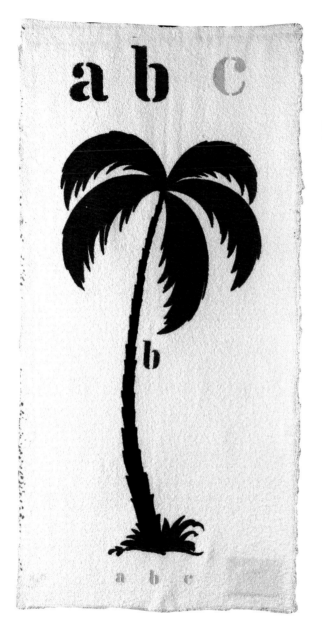

FIG. 21. **MARCEL BROODTHAERS** *ABC*, 1975
TOWEL AND PAINT

transgressive materiality can become a signifier of precisely the aesthetic that it is supposed to transgress. Barthes suggests a strategy of making this very process of recuperation into the object of an "artificial"—as opposed to a naturalizing—myth: "Since myth robs language of something," he writes, "why not rob myth?"[14] The various "sections" of Broodthaers's *Museum of Modern Art, Department of Eagles*, 1968–72, which operate in this manner on the "myth" of aesthetic value, seem to have offered a way to continue the avant-garde project, even in the context of its failure. They do so in an "allegorical" mode.[15] As opposed to the sublimations of symbolic expression

FIG. 22. **MARCEL BROODTHAERS** INSTALLATION VIEW, *MARCEL BROODTHAERS* EXHIBITION, MARIAN GOODMAN GALLERY, NEW YORK, 1995. ON THE WALL AT RIGHT: *THE CROW AND THE FOX*, 1976; ON THE WALL AT LEFT: *THE CROW AND THE FOX*, 1967

that would raise matter to meaning or purified idea, allegory, which splits the material signifier apart from its symbolic meaning, rendering the latter arbitrary, makes apparent the materiality of the signifier. This disjunctive quality of allegory is perhaps the other, mournful face of the attempt during the 1960s and 1970s to discover and develop new modes of materiality, no longer as the servant of form or as its filling but as the harbinger of new ways of life as yet unrealized.

1. Weiner, quoted in Benjamin H. D. Buchloh in conversation with Lawrence Weiner, Alexander Alberro et al., *Lawrence Weiner* (London: Phaidon, 1998), p. 13.

2. Ibid., p. 44.

3. Lawrence Weiner, letter to Wieslaw Borowski, Galeria Foksal, Warsaw, June 2, 1979, Foksal Archive.

4. This conception of exposure comes from Jean-Luc Nancy, *The Sense of the World* (Minneapolis and London: University of Minnesota Press, 1997); see also Jean-Luc Nancy, *Technique du présent: essai sur On Kawara*, Cahiers-Philosophie de l'art (Villeurbanne, France: Nouveau Musée/Institut d'art contemporain, 1997).

5. See Jean-Luc Nancy, *The Muses*, trans. Peggy Kamuf (Stanford, Calif.: Stanford University Press, 1996), pp. 81–100, on art as "vestige."

6. Jessica Bradley and Matthew Teitelbaum, eds., *The Art of Betty Goodwin* (Toronto: Art Gallery of Ontario, 1998), p. 10.

7. Michael Corris makes this point in "From black holes to boardrooms: John Latham, Barbara Steveni & the order of undivided wholeness," *Art + Text*, no. 49 (Sept. 1994), pp. 66–72.

8. See Germano Celant, *Piero Manzoni* (London and Milan: Serpentine Gallery and Charta, 1998), p. 29. Benjamin H. D. Buchloh discussed this notion of the vestige in "Piero Manzoni: Administering Abstraction," a lecture at the Royal College of Art, London, on April 23, 1998.

9. Michael Compton, *Marcel Broodthaers* (Minneapolis: Walker Art Center, 1989), p. 21.

10. Manzoni's canned *Artist's Shit* (Merda d'artista) series of 1961, which uses a similar strategy to reflect on the value of the work, is a precedent for this piece.

11. See Kathryn Chiong, "Nauman's Beckett Walk," *October*, no. 86 (Fall 1998), pp. 63–81; and Gijs van Tuyl, "Human Condition/Human Body: Bruce Nauman and Samuel Beckett," in *Bruce Nauman* (London: Hayward Gallery, 1998), pp. 60–75. Rosalind Krauss uses Beckett as an interpretative tool to approach the existential structure of LeWitt's work in "LeWitt in Progress."

12. Broodthaers's oeuvre could be understood as an extended reflection on the vicissitudes of Mallarméan modernism. See Richard Cándida Smith, *Mallarmé's Children: Symbolism and the Renewal of Experience* (Berkeley, Los Angeles, London: University of California Press, 1999); and Birgit Pelzer, "Marcel Broodthaers: The Place of the Subject," in Michael Newman and Jon Bird, eds., *Rewriting Conceptual Art: Critical Views* (London: Reaktion, 1999), pp. 186–205.

13. Roland Barthes, *Mythologies*, trans. Annette Lavers (St. Albans, Eng.: Paladin, 1973), p. 132.

14. For a discussion of this, see Rainer Borgemeister, "Section des Figures: The Eagle from the Oligocene to the Present," in Benjamin H. D. Buchloh, ed., *Broodthaers: Writings, Interviews, Photographs*, Cambridge, Mass. and London: MIT Press, 1988, pp. 135–51.

15. See Craig Owens, "The Allegorical Impulse: Toward a Theory of Postmodernism," in *Beyond Recognition: Representation, Power, and Culture* (Berkeley: University of California Press, 1992), pp. 52–87; and Douglas Crimp, *On the Museum's Ruins* (Cambridge, Mass., and London: MIT Press, 1993), pp. 200–234.

Michael Newman is principal lecturer in research at Central Saint Martins College of Art and Design, London. He has written extensively on contemporary art, including essays on James Coleman, Hanne Darboven, Richard Deacon, Douglas Gordon, Steve McQueen, and Jeff Wall, as well as theoretical texts on modernism, the relation of criticism and philosophy, and on historiography.

32. **MANGELOS** *MANIFESTO ABOUT THINKING, NO.1,* 1978
ACRYLIC ON BOARD

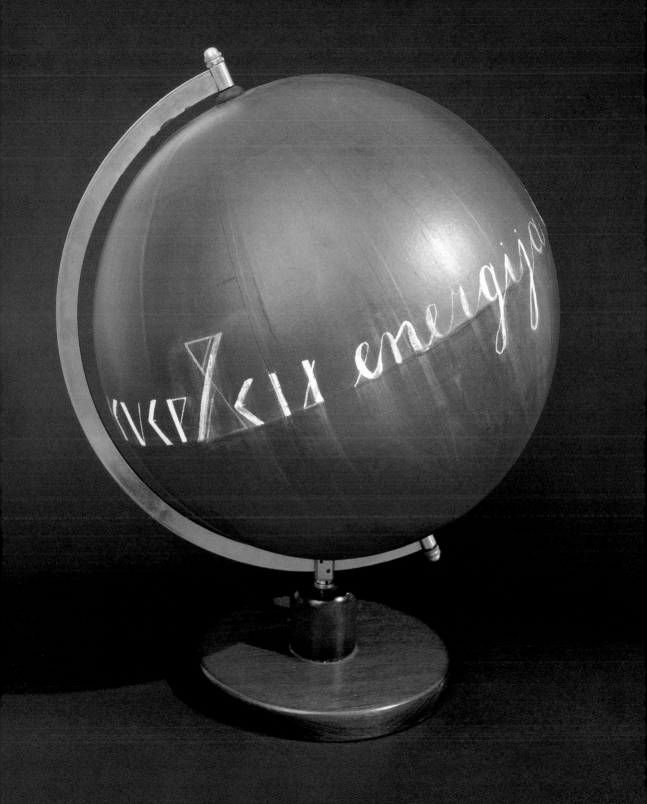

33. **MANGELOS** *ENERGY*, 1978
ACRYLIC AND OIL ON GLOBE OF WOOD, METAL, AND PRINTED PAPER

MANGELOS
34. PYTHAGORA 2, 1953
PAINTED BOOK: TEMPERA AND OIL ON TWENTY-SEVEN SHEETS OF
PRINTED COATED PAPER, BOUND IN CLOTH-COVERED BOARDS

35. ALFABET, 1952
PAINTED BOOK: TEMPERA ON TWENTY-FOUR SHEETS OF
PRINTED COATED PAPER, STAPLE-BOUND IN PAPER COVERS

36. **PIERO MANZONI** *ACHROME*, 1960
PEBBLES AND COBALT CHLORIDE ON CANVAS

CORPO D'ARIA Esemplare n. 29 A

PIERO MANZONI

Questa scatola contiene l'involucro e la base per un "corpo d'aria" di
metro massimo di cm. 80, approntati e confezionati tra il 10 [...]
contiene inoltre un bocchino per il gonfiamento a fiato [...]
a disposizione una pompa.

Diametro ma[...]

37. **PIERO MANZONI** *BODY OF AIR*, 1959–60
WOODEN BOX WITH BALLOON, METAL STAND, PLASTIC TUBING, PRINTED
INSTRUCTIONS, AND PHOTOGRAPH

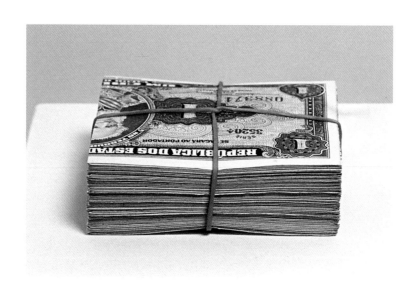

CILDO MEIRELES

38. *SOUTHERN CROSS*, 1969–70
WOOD (PINE AND OAK)

39. *MONEY TREE*, 1969
100 FOLDED ONE-CRUZEIRO NOTES AND TWO RUBBER BANDS

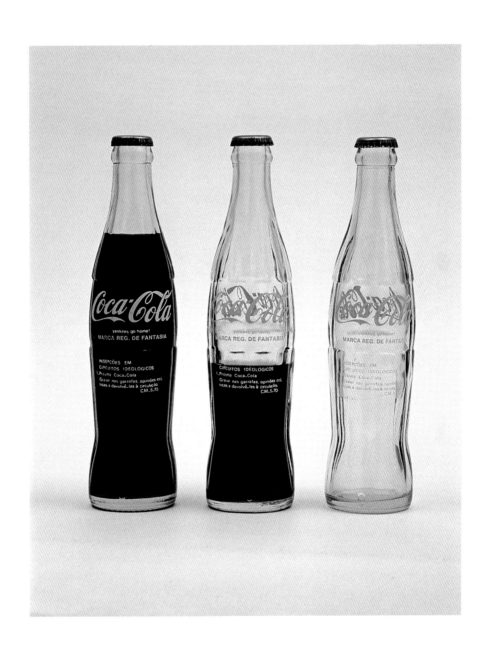

40. **CILDO MEIRELES** *INSERTIONS INTO IDEOLOGICAL CIRCUITS: COCA-COLA PROJECT*, 1970
COCA-COLA BOTTLES AND TRANSFERRED TEXT

LOOKING BACK,
LOOKING AHEAD:
THE
RESONANCE
OF THE 1960S
AND 1970S
IN
CONTEMPORARY
ART

In the 1960s, many artists became engaged with historical, philosophical, or political concerns that inspired them to seek alternatives to the object as the end result of artistic practice. Whether these concerns were based on notions of art-historical progress, linguistic or analytic philosophy, or anti-capitalist politics, artists around the world increasingly came to depend on the impalpable concept as the substance of art. However, finding it impossible (or simply uninteresting) to let the art object vanish into the empyrean of pure Idea, artists of the 1960s and 1970s continued to use everyday materials to ground their immaterial concerns in the stuff of human perception and life experience. As noted by Carin Kuoni, "Their explicit acknowledgment of the importance of the physical aspect of the work places them squarely in the contested zone where the call to make an immaterial philosophical statement spars with the desire to create an actual work, using non-traditional, ordinary materials."[1]

After a return to painterly expressionism in the 1980s, artists in the 1990s began again to turn to the art of the 1960s and 1970s in search of models of practice that were both conceptual and material, participatory and ephemeral, critical and sensuous. Young artists today have absorbed the lessons of Conceptualism and seem comfortable taking these strategies for granted as they work with a variety of approaches to the manipulation of physical material. The renewed interest in the achievements of an earlier generation has been fueling some of the most compelling art of the turn of the millennium.

Perhaps the most common tension surrounding the art object in the 1960s and 1970s (at least in the non-Communist West) was its status as a commodity. The move away from objects was often tied to an effort to subvert art's commercial status and return it to a purely social or aesthetic function. Many artists paid no attention to the art market, creating works that were difficult if not impossible to sell. Others, such as Marcel Broodthaers, Piero Manzoni, and Cildo Meireles, positioned their art within the economic system so that it could play a critical or subversive role. In the 1990s, artists began again to address these issues; however, for the most part their approach has been to embrace the monetary system of exchange as a neutral vehicle—a "primary structure," if you will—to be shaped and molded according to the requirements of a particular piece.

Among the most important examples of such practice are works by the American collective RtMark and French artist Fabrice Hybert. Physical objects are essential components of the art of both: for RtMark, in terms of destruction;

FIG. 23. **RTMARK** *BARBIE LIBERATION ORGANIZATION*, 1993 (DETAIL) WEB SITE

for Hybert, in terms of play. RtMark encourages the "alteration" of commercial products, especially children's toys, games, and learning tools. Their first highly publicized project involved channeling funds to the Barbie Liberation Organization which, in 1993, switched the voice boxes of three hundred G.I. Joe and Barbie dolls (see fig. 23). Another notorious bit of commercial sabotage funded through RtMark was the reprogramming of eighty thousand copies of the popular electronic game Simcopter, which was altered to include homoerotic content. Like the modified Coke bottles in Cildo Meireles's *Insertions into Ideological Circuits: Coca-Cola Project*, 1970 (plate 40), these products were returned to the stores to make their way into consumers' hands and homes. On their Web site, RtMark.com, the collective provides news and information, parodying political and corporate propaganda, and allows visitors to invest directly in one of

their "mutual funds," which finance the group's subversive actions.[2]

Hybert takes a less risky but no less subversive approach to commenting on the market-driven dimension of art production. His recent objects (which he calls "Prototypes of Functioning Objects" or P.O.F.s) are intended to inspire new behaviors through the user's own imaginative, physical interaction with the pieces (figs. 24a and 24b). The P.O.F.s recall Hélio Oiticica's anarchic *Parangolés*, 1964–67 (plates 43 and 44), wearable or inhabitable art forms that Oiticica believed could facilitate a more creative experience of everyday life by disrupting behavioral norms and unlocking a kind of latent *jouissance*. However, the overtly—even ecstatically—commercial dimension of Hybert's project would have been unthinkable in the 1960s and 1970s: Hybert has created a fully functioning business, Unlimited Responsibility (UR), as a vehicle for the devel-

opment and marketing of his P.O.F.s. He employs a kind of reverse industrial-design process: instead of creating forms to meet the needs of new behaviors, Hybert develops behaviors to meet the needs of new forms, such as a cubic soccer ball. By means of audience-survey forms, he tracks possible "uses" of the P.O.F.s, pinpoints particularly successful objects, and then generates new ones. It would be a mistake to see Hybert's work simply as market research, with his audience functioning as a kind of amorphous focus group. Ultimately, his work is more about fantasy than reality, or, perhaps, fantasy *in* reality. Of this process, Hybert has said, "Nothing creates itself, everything transforms. The artist is there for charging these transformations with meaning and humanness. The main thing is. . .the possibility of. . . a revalorization of forms, and a re-evaluation of commodities (objects or services) that surround us."[3]

Many artists of the 1990s, like those of the 1960s and 1970s, focus on art's interactive, instrumentalist potential. In the 1960s and 1970s, Latin American artists in particular emerged from the formalist box of high modernism into an expanded field of social engagement. Both Oiticica and Lygia Clark, for example, transformed Concretism—a

practice dedicated to the reduction of form, color, and shape to what were conceived as perceptually direct or absolute aesthetic conditions—by playing out its premises to their fullest extent. "It was during his initiation to samba," writes Simone Osthoff, "that [Oiticica] went from the visual experience in all its purity to an experience that was tactile, kinetic, based on sensual fruition of materials, where the whole body, which in the previous phase was centered on the distant aristocracy of the visual, became the total source of the sensorial."[4] Clark, meanwhile, moved progressively from considerations of external form to explorations of internal experience, which ultimately evolved into a highly interactive, psychologically therapeutic art.

Like Oiticica and Clark, Chicago-based artist Iñigo Manglano-Ovalle creates participatory sculptural environments that are designed to catalyze spontaneous human relationships and transformative experiences. Pieces such as *The El Niño Effect*, 1997, and *SAD*

FIGS. 24A AND 24B.
FABRICE HYBERT
P.O.F. #3—SWING, 1990
LATEX RUBBER, WOOD,
AND SYNTHETIC ROPE

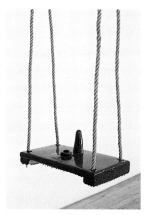
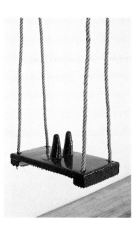

FIG. 25. **IÑIGO MANGLANO-OVALLE** *SAD LIGHT ROOM*, 1999
PAINTED STEEL, VINYL, FLOURESCENT LAMPS, SPEAKERS, COMPACT-DISC AUDIO TRACK

Light Room, 1999 (fig. 25), call for pairs of spectators—often strangers to one another—to engage with the work on both a physical and a psychological level. *The El Niño Effect* consists, in part, of two sensory-deprivation tanks that can be occupied for periods of up to an hour in a state of deep meditative self-awareness. The vaguely New Age aspect of the work is undercut by the presence of a soundtrack that may seem to the casual viewer like breaking waves, but which is actually the much-sloweddown echo of a gunshot. *SAD Light Room* similarly presents a kind of therapeutic social encounter with an ironic undercurrent. In this piece, two spectators recline on side-by-side, white, high-modern chaise lounges, while from above they are bathed in a specially balanced light. This light, known as SAD (Seasonal Affective Disorder) light, has been developed to cure depression in people who live in parts of the world that receive too little

sunlight each day during the winter months. While *SAD Light Room* exists ostensibly to cheer up the grumpy spectator, the environment that the artist has created is uncomfortably sterile and intentionally vacuous. The irony and ambiguity of Manglano-Ovalle's work distinguish it from the considerably more idealistic and utopian art of Oiticica and Clark.

Joseph Grigely is another contemporary artist creating art that is inseparable from social interaction. Grigely, who has been deaf since the age of eleven, makes his art—which he calls "Conversations with the Hearing"— from the brief notes passed to him by various interlocutors: friends, acquaintances, and strangers (see fig. 26). Grigely assembles these small pieces of paper into groups, drawing subtle links between the discontinuous texts and making purely formal connections based on such properties as color. His accumulations of notes are an interesting counterpoint to

the cryptic text pieces that Croatian artist Mangelos created during the three decades from World War II through the 1970s. Although Grigely's art may seem offhand and whimsical in comparison to the existential weight of Mangelos's practice, the work of both metonymically alludes to a larger universe of thought and experience and shares an underlying engagement with a profound sense of absence. Mangelos's first pieces, for example, consist of pages on which he recorded the deaths of neighbors, friends, cousins, and acquaintances. In Grigely's work, a haunting silence overtakes us as we come to realize that the only person whose comments are not present are those of the artist himself.

Another strong current connecting the 1960s and 1970s to contemporary practice is a genre of work that incorporates everyday, sometimes found, materials to create provocative interventions in daily experience. Since 1970, Polish artist Edward Krasiński has created art almost exclusively from blue Scotch tape, 19 mm (3/4 inch) wide and applied to just about any surface in his vicinity (trees, walls, windows, etc.), at a constant height of 130 cm (51 1/8 inches). With this simple, repeated gesture, Krasiński combines the rigor of Concrete art and Conceptualism with the absurdity and humor of Surrealism and Dada. According to Krasiński, "[The stripe] unmasks reality to which it is stuck.... It can appear anywhere.... Through pure picture and the blue line I sanction a given place as the place of art."[5] A con-

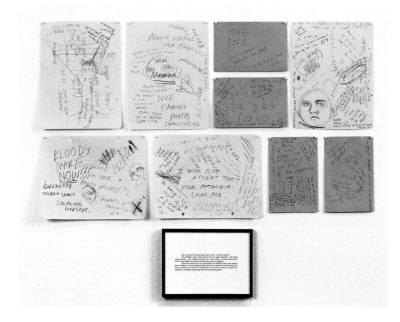

FIG. 26. **JOSEPH GRIGELY**
UNTITLED CONVERSATIONS
(SUSAN'S MARTINI PARTY), 1996
FRAMED TEXT AND NINE SHEETS OF PAPER

FIG. 27. **MARTIN CREED** *WORK NO. 200: HALF THE AIR IN A GIVEN SPACE*, 1998
14, 215 TWELVE-INCH WHITE BALLOONS FILLED WITH AIR

temporary counterpart to Krasiński (who is still putting up his blue tape) is Martin Creed, a young English artist who similarly marks spaces with simple interventions that are simultaneously measured and ludicrous. A typical Creed piece is *Half the Air in a Given Space*, 1998 (fig. 27), which consists simply of balloons that have been filled with exactly half the volume of air in a given space in which the work is shown. This seemingly innocuous, even festive, act turns into an exercise in terror and claustrophobia when spectators find themselves unable to escape the suffocating balloon-filled environment. Like Krasiński, whose blue tape may wend its way through a group exhibition, Creed has created ambient works that borrow the space around them, including, at times, the works of other artists.

Creed's sole contribution to a recent group exhibition, for example, was a piece that consisted of turning the gallery lights on and off at regular intervals.

Andrea Fraser is even more radical than Creed in her rejection of conventional artistic forms and critical embrace of quotidian experience. Recalling project-based works such as Mierle Laderman Ukeles's *Maintenance Art Project*, 1969–70, or Gordon Matta-Clark's SoHo restaurant *Food*, 1971–73, Fraser has developed a practice that involves responding to various requests for services. In 1994, for example, she was hired to "study the function of the art of the Generali Foundation: the result is a comprehensive report and analysis of a model seeking to implement art as image and communicational instrument in a private economy or in the

world of work"[6] (see *A Project in Two Phases [The EA-Generali Headquarters, Vienna]*, 1994–95, fig. 28). Fraser's finished piece consists of thirteen wall-mounted texts incorporating photographs and interviews that she conducted with the Board of Governors, the Advisory Board, and the staff of the Generali Foundation. Fraser's work, which doesn't shy away from a critical engagement with the commissioning institution, echoes Hans Haacke's anti-institutional investigations, although Fraser positions her art subversively within the very system of corporate, capitalist enterprise that she critiques.

The response today to the art of the 1960s and 1970s is often indirect and sometimes even based on a faulty sense of history. In *An Inadequate History of Conceptual Art*, 1999 (fig. 29), Silvia Kolbowski borrows the analytical, affectless mode of some 1960s Conceptual art to investigate contemporary artists' anecdotal recollections of the art of those earlier decades. In her letter to potential artist participants in the project, Kolbowski wrote:

> The focus of the project is the current resurgent interest in Conceptual art of the 1960s and 1970s, and this work's reappearance in various forms in galleries, museums, international shows, the media, the academy and the work of a new generation. . . . Compared to the 1980s, when such work was barely mentioned in the U.S., this new interest seems significant. . . The project seeks to question the seamless nature of the current "return."[7]

Kolbowski's finished piece consists, in parts, of audio recordings that she made with twenty-two artists—most of whom were themselves

FIG. 28. **ANDREA FRASER**
A PROJECT IN TWO PHASES
(THE EA-GENERALI HEADQUARTERS, VIENNA),
1994–95 (DETAIL)
INSTALLATION

involved with Conceptual practices in the 1960s and 1970s—in which they describe Conceptual works that made a powerful initial impression on them. As we listen to the recorded sessions, we become aware of the imprecision of their recollections of works that often were created with little or no material form. In addition to the audio component, Kolbowski's piece includes a laser-disc projection showing images of the artists' hands as they speak. Their hands are not synchronized with their voices, which becomes evident, for example, when we hear a man's voice and see a woman's hands. Furthermore, the audio and video components—the former played on a high-end Bang & Olufsen sound system and the latter on a relatively low-tech, floor-mounted three-beam projector—are played in separate, adjacent rooms. Through such disjunctions, Kolbowski suggests an underlying fracture of perception and understanding, while commenting on the difficulty—if not impossibility—of establishing an unmediated connection to our aesthetic forebears.

Although our digitized, post–Cold War world bears little resemblance to the Europe of Joseph Beuys, the Brazil of Lygia Clark, the Soviet Union of Ilya Kabakov, or the United States of Eva Hesse, the art of the 1960s and 1970s has captured the imagination of a new generation of international artists. While many of the lessons of the 1960s and 1970s remain valid, it would be foolish to assume that these earlier strategies can be simply and uncritically adopted in the present. Despite their similar balancing of material and concept, the artists of the 1960s and 1970s represented in *Beyond Preconceptions* were engaged with a diversity of profoundly local social, political, and cultural issues. With the explosion of large-scale international survey exhibitions and the accompanying globalization of the contemporary art

FIG. 29. **SILVIA KOLBOWSKI**
AN INADEQUATE HISTORY OF CONCEPTUAL ART, 1999
(DETAIL)
VIDEOTAPE AND AUDIO RECORDINGS

market, the tendency of more recent art is to lose that specificity. Art has come unmoored from its locales to float freely and ambiguously in a global art world that is increasingly self-aware and self-referential. In this atmosphere, it is becoming increasingly difficult to tell one artist's work from another. Rather than see this as a problem, and long nostalgically for the intense if relatively atomized conditions of the 1960s and 1970s, we must face the reality of the present and come to terms with the conditions produced by the expansion-driven art market, art media, and art institutions, which—paradoxically—are both energizing and enervating. The single most important lesson that can be gleaned from the work of the 1960s and 1970s is its anti-dogmatism. Artists are increasingly inspired by works that succeed in weaving dualities together: conceptual and material, public and private, and commercial and altruistic dimensions. It is in the complex arena of dynamic, fluid identities, rather than in the comforting territory of solipsism and style, that the most innovative and influential works of the early twenty-first century will be made.

1. Carin Kuoni, "Beyond Preconceptions: The Sixties Experiment," exhibition proposal (New York: Independent Curators International, 1999), p. 1.
2. http://www.RtMark.com, 1999.
3. Fabrice Hybert, quoted in a press release for *Diététique* (Poitiers, France: Le Confort Moderne, 1998).
4. Simone Osthoff, "Lygia Clark and Hélio Oiticica: A Legacy of Interactivity and Participation for a Telematic Future," in *Leonardo* 30, no. 4 (August 1997), pp. 279-82.
5. Krasiński, quoted in Dorotea Monkiewicz, *Edward Krasiński*, Kunsthalle Basel, 1996.
6. Sabine Breitwieser, "Collection,"http://www.gfound.or.at/index_e.htm.
7. Silvia Kolbowski, "Sample of Letter Sent to Artists Who Were Asked to Participate in An Inadequate History of Conceptual Art/Silvia Kolbowski," one page hand-out, 1999.
8. The following artists are included in *An Inadequate History of Conceptual Art*: Vito Acconci, Dennis Adams, Mac Adams, Connie Beckley, Dara Birnbaum, Mel Bochner, Hans Haacke, Eileen Hickey-Hulme, Mary Kelly, Joyce Kozloff, Louise Lawler, Les Levine, Alan McCollum, Jonas Mekas, Howardena Pindell, Lucio Pozzi, Yvonne Rainer, Dorothea Rockburne, Allen Ruppersberg, Carolee Schneemann, Lawrence Weiner, and James Welling.

Lawrence R. Rinder is the curator of contemporary art at the Whitney Museum of American Art, New York, where he was co-curator of the *2000 Biennial*. The former director of the California Institute of Arts and Crafts, San Francisco, Rinder was also a curator of the MATRIX galleries at the University of California, Berkeley Art Museum, where he organized exhibitions with work by artists such as Sophie Calle, Felix Gonzalez-Torres, Dieter Roth, Cindy Sherman, and Kiki Smith.

41. **BRUCE NAUMAN** *STUDIES FOR HOLOGRAMS*, 1970 (DETAIL)
PORTFOLIO OF FIVE SCREENPRINTS

42. **HÉLIO OITICICA** *BOX BOLIDE 8*, 1964
OIL ON WOOD, YELLOW PLASTIC, AND NYLON NET

HÉLIO OITICICA

43. (LEFT) *PARANGOLÉ P16 CAPE 12: OF ADVERSITY WE LIVE*, 1964
COTTON WITH TEXT, PLASTIC BAG WITH VARIOUS OBJECTS, AND NYLON NET

44. (RIGHT) *PARANGOLÉ P4 CAPE 1*, 1964
OIL AND ACRYLIC ON TEXTILE, PLASTIC, AND NYLON NET

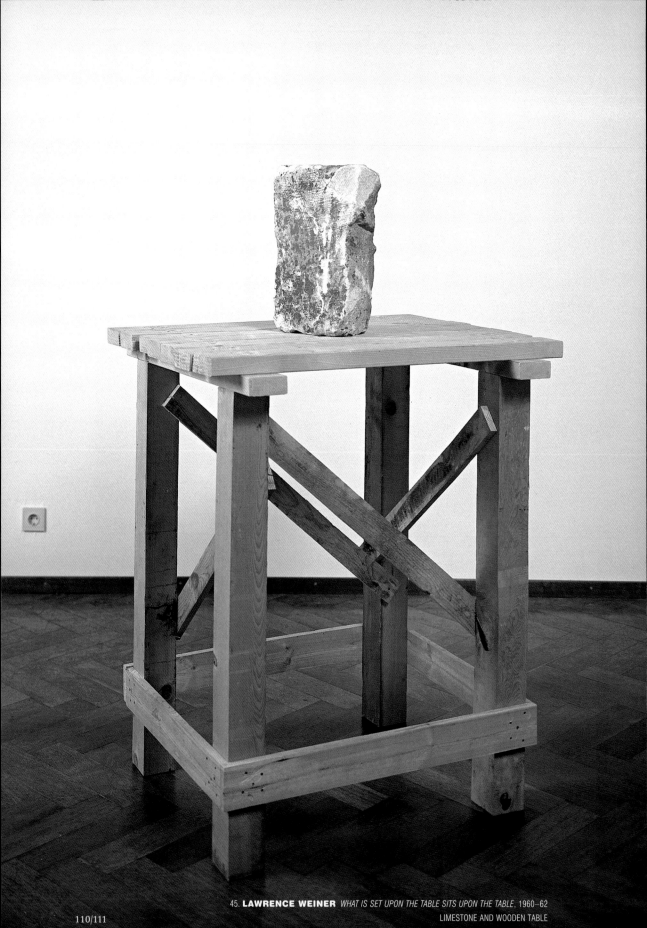

45. **LAWRENCE WEINER** *WHAT IS SET UPON THE TABLE SITS UPON THE TABLE*, 1960–62
LIMESTONE AND WOODEN TABLE

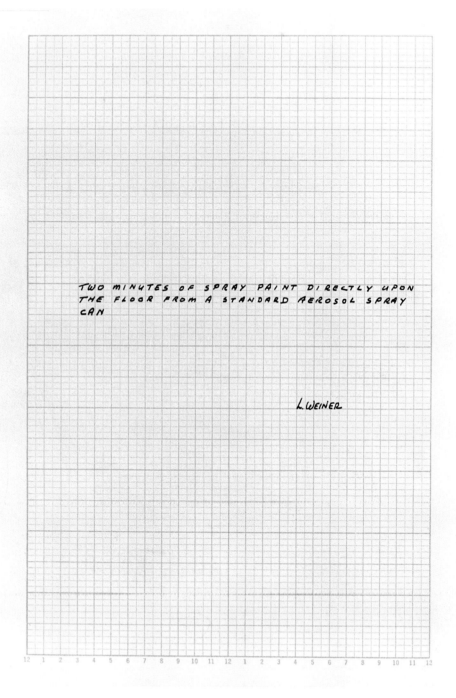

46. **LAWRENCE WEINER** *TWO MINUTES OF SPRAY PAINT DIRECTLY UPON THE FLOOR FROM A STANDARD AEROSOL SPRAY CAN*, 1967 (DETAIL)
INK ON PAPER

EXHIBITION CHECKLIST

JOSEPH BEUYS

JaJaJaJaJaNeeNeeNeeNeeNee, 1970
Album with long-playing record, stamped
31 x 31 cm (12 1/4 x 12 1/4 inches)
Edition: no. 139 of 500
Courtesy Ronald Feldman Fine Arts, New York

Felt Suit (Filzanzug), 1970
Felt
168.8 x 76.8 x 21.6 cm (67 1/2 x 30 1/4
x 8 1/2 inches)
Collection of Chase Manhattan Bank

*How the Dictatorship of the Parties Can Be
Overcome (Wie die Parteiendiktatur überwunden
werden kann)*, 1971
Printed polyethylene shopping bag with
sheets of paper (information passed out
at *Documenta 5*, 1972)
Bag: 75 x 51.5 cm (29 1/2 x 20 1/4 inches)
Courtesy Ronald Feldman Fine Arts, New York

*Fingernail Impression in Hardened Butter
(Fingernagelabdruck aus gehärteter Butter)*, 1971
Butter, wax, plastic box, and gray cardboard
24 x 21 x .2 cm (9 1/2 x 8 1/4 x 7/100 inches)
Edition: no. 73 of 150
Courtesy Ronald Feldman Fine Arts, New York

I Know no Weekend (Ich in der Küche), 1971–72
Sauce bottle and book by Immanuel
Kant, *Critique of Pure Reason* (Kritik der
reinen Vernunft)
53 x 66 x 11 cm (20 7/8 x 26 x 4 3/8 inches)
Edition: no. 23 of 95
Courtesy Ronald Feldman Fine Arts, New York

The Revolution Is Us (La rivoluzione siamo Noi), 1972
75 x 39 cm (30 x 15 1/2 inches)
Seriograph on paper with writing
Edition: no. 119 of 188
Collection of New School University, New York

Noiseless Blackboard Erasers, 1974
Five blackboard erasers
Each 5 x 12.5 x 2.5 cm (2 x 4 7/8 x 1 inches)
Edition: 550
The Carol and Arthur Goldberg Collection,
New York

Bruno Cora Tea, 1974
Coca-Cola bottle containing herb tea, with
lead seal and label, in wooden box with glass
28.5 x 11 x 10.5 cm (11 1/4 x 4 3/8 x
4 1/8 inches)
Edition: no. 7 of 40
Courtesy Ronald Feldman Fine Arts, New York

MARCEL BROODTHAERS

AAA Art, 1967
Plywood pedestal and paint
100 x 30.5 x 30.5 cm (39 3/8 x 12 x 12 inches)
Private collection, courtesy Marian Goodman
Gallery, New York

The Crow and the Fox (Le corbeau et le renard), 1967
Typograph from mixed-media work
89.4 x 128.1 cm (35 3/4 x 51 1/4 inches)
Collection of Raymond Learsy

Porte A, 1969
Enamel and plastic
82.6 x 116.2 cm (32 1/2 x 45 3/4 inches)
Collection of Neuberger Berman, New York

*Journal of a Utopian Voyage
(Journal d'un Voyage Utopique)*, 1973
China ink on paper
50.8 x 43 cm (20 x 16 7/8 inches)
Collection of George H. Coppers

Palette, 1973
Pencil on paper
13.5 x 11.5 cm (5 3/8 x 4 1/2 inches)
Collection of George H. Coppers

ABC, 1975
Towel and paint
104 x 51 cm (41 x 20 1/8 inches)
Collection of George H. Coppers

The Crow and the Fox (*Le corbeau et le renard*), 1976
One print from a series of five, edition of 40
60.6 x 80 x 5 cm (24 1/4 x 32 x 2 inches)
Collection of Raymond Learsy

LYGIA CLARK

Rubber Grub (*Obra Mole*), 1964 (reconstruction)
Black rubber
Variable dimensions
Collection of Family Clark, Museu de
Arte Moderna, Rio de Janeiro

Animal (*Bicho*), 1966 (reconstruction)
Aluminum
Variable dimensions
Collection of Family Clark, Museu de
Arte Moderna, Rio de Janeiro

Stone and Air (*Pedra e ar*), 1966 (reconstruction)
Ten stones and plastic
29 x 35 x 6 cm (11 1/2 x 14 x 2 1/2 inches)
Collection of Family Clark, Museu de
Arte Moderna, Rio de Janeiro

The I and the You: Cloth-Body-Cloth Series
(*O eu e o tu: Série roupa-corpo-roupa*), 1967
(reconstruction)
Rubber
Two pieces, each approximately 193 x 30.5 x
30.5 cm (76 x 12 x 12 inches)
Collection of Family Clark, Museu de
Arte Moderna, Rio de Janeiro

HANNE DARBOVEN

Untitled, 1.1.74–31.1.94
(*Ohne Titel, 1.1.74–31.1.94*), 1974–94
Ink on vellum
Set of thirty-one drawings
Each 30.2 x 21 cm (11 7/8 x 8 1/4 inches)
The Carol and Arthur Goldberg Collection

Merry Is the Gypsy's Life (*Lustig ist das
Zigeunerleben*), 1979
Portfolio of thirty-one lithographs
Each 42 x 29.7 cm (16 1/2 x 11 3/4 inches)
Edition: no. 194 of 250
Courtesy Edition Schellmann,
Munich-New York

BETTY GOODWIN

Crushed Vest, 1971
Fabric treated with resin, and Plexiglas
51.1 x 63.5 x 10.2 cm (20 1/8 x 25 x 4 inches)
Collection of the artist, courtesy Galerie
René Blouin, Montreal

Parcel, ca. 1971
Cement and plaster
5.7 x 9.2 x 9.2 cm (2 1/4 x 3 5/8 x 3 5/8 inches)
Collection of the artist, courtesy Galerie
René Blouin, Montreal

Feather Nest, 1972
Hair, feather, fabric, and pigment on mat board
36.2 x 28.6 x 3.8 cm (14 1/4 x 11 1/4 x 1 1/2 inches)
Collection of the artist, courtesy Galerie
René Blouin, Montreal

Rolled Tarpaulin, 1973
Tarpaulin and painted wood
91.4 x 23.2 x 18.4 cm (36 x 9 1/8 x 7 1/4 inches)
Collection of the artist, courtesy Galerie
René Blouin, Montreal

Black Vest Fragment, 1974/1976
Conté crayon, ink, glue, and gesso on fabric;
pins, gouache, graphite, and colored
pencil on paper
55.2 x 40 cm (21 3/4 x 15 3/4 inches)
Collection of the artist, courtesy Galerie
René Blouin, Montreal

Tarpaulin #10 (Passage for a Tall Thin Man),
1974–91
Tarpaulin, oil, staples, and cord
289.9 x 94.9 x 25.4 cm (114 1/8 x 37 3/8 x
10 inches)
The Bailey Collection, Toronto

VICTOR GRIPPO

Analogy IV (Analogía IV), 1972
Potatoes, plates, knives and forks, transparent
Perspex potatoes, wooden table, and
tablecloth of white cotton and black velvet
75.6 x 59 x 94.5 cm (29 3/4 x 23 1/4 x 37 1/4 inches)
Collection of Jorge and Marion Helft,
Buenos Aires

Synthesis, 1972 (reconstruction)
Potato and charcoal
Each approximately 15.2 cm diam. (6 inches)
Collection of Catherine de Zegher

Igne, 1979
Rosebush twigs, lead rose, lead sheet,
glazed wooden box, and metal handle
33 x 50 x 14.5 cm (13 x 19 5/8 x 5 3/4 inches)
Collection of Mirella and Daniel Levinas,
Bethesda, Maryland

EVA HESSE

Untitled, 1965
Ink, gouache, and watercolor on paper
41.9 x 29.2 cm (16 1/2 x 11 1/2 inches)
Collection of Weatherspoon Art Gallery, The
University of North Carolina at Greensboro,
Gift of Mrs. Helen Hesse Charash, 1986

Untitled, 1965
Ink on paper
64.1 x 48.9 cm (25 1/4 x 19 1/4 inches)
Estate of Eva Hesse, courtesy Galerie Hauser
& Wirth, Zürich

Untitled, 1965
Ink on paper
21 x 29.5 cm (8 1/4 x 11 5/8 inches)
Estate of Eva Hesse, courtesy Galerie Hauser
& Wirth, Zürich

Untitled, 1965
Ink on paper
21.6 x 29.5 cm (8 1/2 x 11 5/8 inches)
Estate of Eva Hesse, courtesy Galerie Hauser
& Wirth, Zürich

Selected works from the *Test Piece* series,
1966–69
Collection of University of California, Berkeley
Art Museum, Berkeley, California,
Gift of Mrs. Helen Hesse Charash

Test Piece, 1966–67
Two units: wood, gray paint, rubber,
nuts and bolts
Each 4 x 11.4 x 12.1 cm (1 5/8 x 4 1/2 x
3 3/4 inches)

Test Piece, 1967–68
Two unfired clay blocks
(test piece for *Sans I*, likely molds for latex units)
One piece 2.2 x 9.2 x 5.7 cm (7/8 x 3 5/8 x 2 1/4
inches); second piece 2.2 x 8.9 x 7 cm (7/8 x
3 1/2 x 2 3/4 inches)

Test Piece, 1967–69
Cardboard and gray paint
H.7.6 cm; diam. 8.3 cm (H. 3 inches; diam.
3 1/4 inches)

Test Piece, 1967–69
Two plaster blocks
One piece 1.3 x 8.9 x 7.9 cm (1/2 x 3 1/2 x 3 1/8
inches); second piece 4.8 x 9.5 x 7.3 cm
(1 7/8 x 3 3/4 x 2 7/8 inches)

Test Piece, 1967–69
Aluminum screen and cheesecloth
12.7 x 48.9 x 15.9 cm (5 x 19 1/4 x 6 1/4 inches)

Test Piece, 1967–69
Two units: molded paper
H. 5 cm, diam. 15.2 cm (H. 2 1/2 inches,
diam. 6 inches)
One piece 15.2 x 5 cm (6 x 2 1/2 inches)
(irregular); second piece 3.5 x 31.1 x 8.9 cm
(1 3/8 x 12 1/4 x 3 1/2 inches)

Test Piece, 1968
Two tripod shapes: canvas and cotton string
12.7 x 30.5 x 30.5 cm (5 x 12 x 12 inches)

Model for Accretion, 1967
Twenty painted cardboard tubes, metal
washers, Sculpmetal, and six vinyl cords
Each tube 52.1 cm (20 1/2 inches) long,
2.5 cm (1 inch) diam.; vinyl cords 437.5 cm
(128 inches) unwound
Collection of Weatherspoon Art Gallery,
The University of North Carolina at Greensboro,
Gift of Mrs Helen Hesse Charash, 1985

Enclosed, 1969
Latex over cloth tape and balloon
27.9 x 12.7 x 5.1 cm (11 x 5 x 2 inches)
Collection of Weatherspoon Art Gallery,
The University of North Carolina at Greensboro,
Museum Purchase, 1985

ILYA KABAKOV

Study for Box with Garbage, 1972
Ink on paper
30 x 40 cm (11 3/4 x 15 3/4 inches)
Collection of the artist

Box with Garbage, 1972
Wooden chair and wooden box,
and found items
Approximately 150 x 150 x 90 cm
(59 x 59 x 35 3/8 inches) overall
Collection of the artist

*10 Characters/Album: Sitting-in-the-Closet
Primakov*, 1972
Book (facsimile edition), 47 pages
51.5 x 35 cm (20 1/4 x 13 3/4 inches)
Collection of the artist

10 Characters/Album: The Flying Komarov, 1972
Book (facsimile edition), 32 pages
51.5 x 35 cm (20 1/4 x 13 3/4 inches)
Collection of the artist

ON KAWARA

Oct. 6, 1967, 1967
Acrylic on canvas
21 x 26 cm (8 1/4 x 10 1/4 inches)
With cardboard box and newspaper clippings
21 x 26 x 10.2 cm (8 1/4 x 10 1/4 x 4 inches)
Collection of the artist

JIŘÍ KOLÁŘ

Isaac and Jacob (*Izák a Jakub*), 1960
Collage on paper
29 x 21 cm (11 3/8 x 8 1/4 inches)
Collection of Jan and Meda Mladek,
Washington, D.C.

The Death of Abel (*Abelova smrt*), 1960
Collage on paper
29 x 21 cm (11 3/8 x 8 1/4 inches)
Collection of Jan and Meda Mladek,
Washington, D.C.

Homage to Larousse, 1961
Chiasmage on board
99 x 70 cm (39 x 27 1/2 inches)
Collection of Galerie Zlatá Husa, Prague

A Silent Poem (*Báseň ticha*), 1962
Assemblage with stones
70 x 50 cm (27 1/2 x 19 5/8 inches)
Collection of the artist

Black Sugar (Ĉerny curk), 1963
Assemblage on board
80 x 60 cm (31 1/2 x 23 1/2 inches)
Collection of Galerie Zlatá Husa, Prague

The First Homage to Magritte
(*První pocta Magrittovi*), 1964
Paper collage on board
45 x 33 cm (17 3/4 x 13 inches)
Collection of Jan and Meda Mladek,
Washington, D.C.

Journey to the Center of the Earth
(*Cesta do Centra země*), 1966
Chiasmage on board
99 x 69 cm (39 x 27 1/8 inches)
Collection of Galerie Zlatá Husa, Prague

EDWARD KRASIŃSKI

Untitled, 1967–68
Steel wire
109 x 24 cm (43 x 9 1/2 inches)
Collection of Paulina Krasiński, courtesy
Galeria Foksal Foundation, Warsaw

Untitled, 1967–68
Wood, steel wire, and cable
113 x 32 x 7 cm (44 1/2 x 12 5/8 x 2 3/4 inches)
Collection of Paulina Krasiński, courtesy
Galeria Foksal Foundation, Warsaw

H6, 1968
Iron pipe, steel wire, and wooden roller
30 x 44 x 320 cm (11 3/4 x 17 3/8 x 126 inches)
Muzeum Sztuki, Lodz, Poland

ABC, 1970
Three wooden rollers, acrylic, and plastic cables
Three parts, each 20 x 4 cm (7 7/8 x 1 5/8 inches)
Muzeum Sztuki, Lodz, Poland

Zyg-Zag, 1970
Wood and oil paint
H. 1.5 cm, diam. 71 cm (H. 1/2 inch,
diam. 28 inches)
Courtesy Galeria Foksal Foundation, Warsaw

JOHN LATHAM

Philosophy and the Practice of, 1960
Signed and painted books, rust, clips,
copper tubes, electric wires, wire
mesh, electric instrument panel, and
plaster on canvas on hardboard
76 x 96 x 23 cm (29 7/8 x 37 3/4 x 9 inches)
Collection of Nicholas Logsdail, London

Skoob Tower, 1964
Plexiglas box with bound magazines,
glass, and metal support
Dimensions variable
Courtesy Lisson Gallery, London

EVEN TSTRUCTU RE, 1966–67
Paper, staples, cards, string, and paint
on hardboard
91 x 122 cm (35 7/8 x 48 inches)
Collection of Barbara Steveni,
courtesy Lisson Gallery, London

Firenze, 1967
Polystyrene foam, books, plastic tubes,
and metal pipes
76 x 57 x 61 cm (29 7/8 x 22 1/2 x 24 inches)
Courtesy Lisson Gallery, London

SOL LEWITT

Double Wall Piece, 1962
Oil on canvas and painted wood
Two parts, each 157.5 x 80 x 14.4 cm
(63 x 32 x 5 3/4 inches)
The LeWitt Collection, Chester, Connecticut

Wooden Piece, 1964
Wood
66.3 x 106.5 x 12.5 cm (26 1/2 x 42 2/3 x 5 inches)
Collection of Paula Cooper

Four Basic Kinds of Line and Colour, 1972
Book of offset prints, published by Lisson
Gallery, London, Studio International,
London, and Paul David Press, New York.
19.7 x 19.7 cm (7 3/4 x 7 3/4 inches)
Edition unknown
Private collection, Washington, D.C.

Five Cubes on Twenty-five Squares, 1977
Plastic and wood
Base: 83.8 x 83.8 x 2.5 cm (33 x 33 x 1 inches);
wall piece: two panels, each 118.1 x 157.5 cm
(46 1/2 x 62 inches)
The Carol and Arthur Goldberg Collection,
New York

ANNA MARIA MAIOLINO

A Secret Place in the Mind (*Lugar secreto
da mente*), 1972
Pencil and thread on paper (Fabriano)
50 x 50 cm (19 5/8 x 19 5/8 inches)
Collection of the artist

IN/OUT (Anthropophagy) (*IN/OUT
[Antropofágia]*), 1973
Videotape, 9 min.
Collection of the artist

Black Hole (*Buraco negro*), 1974
Paper (Fabriano) and thread in
wooden box covered with glass
70 x 70 x .9 cm (27 1/2 x 27 1/2 x 3/8 inches)
Collection of the artist

+ – = – (Plus Minus Equals Minus), 1976
Videotape, 3 min. 37 sec.
Collection of the artist

Loose Line (*Linha solta*), 1976
Thread on paper (Fabriano) in
wooden box with glass
55 x 38 x 14.5 cm (21 5/8 x 15 x 5 3/4 inches)
Collection of the artist

Over a Line (*Sobre a linha*), 1976
Thread on paper (Fabriano) in
wooden box with glass
70 x 70 x 6 cm (27 1/2 x 27 1/2 x 2 3/8 inches)
Collection of the artist

On the Line (*Na Linha*), 1976
Book object: Black paper (Murillo) and thread
Approximately 28 x 28 x 2 cm
(11 x 11 x 3/4 inches)
Edition: no. 10 of 100
Collection of the artist

Point to Point (*Ponto a ponto*), 1976
Book object: Paper (Murillo) and thread
20.5 x 27 x .5 cm (8 x 10 5/8 x 1/4 inches)
Edition: no. 11 of 100
Collection of the artist

Trajectory I (*Trajetória 1*), 1976
Book object: Black paper (Murillo), acrylic ink,
and thread
20.5 x 27 x .5 cm (8 x 10 5/8 x 1/4 inches)
Edition: no. 1 of 100
Collection of the artist

Trajectory II (*Trajetória II*), 1976
Book object: Paper (Murillo) and thread
20.5 x 27 x .5 cm (8 x 10 5/8 x 1/4 inches)
Edition: no. 8 of 100
Collection of the artist

Itineraries (*Percursos*), 1977
Book object: Paper (Murillo) and thread
30 x 30 x .3 cm (11 3/4 x 11 3/4 x 1/8 inches)
Edition: no. 11 of 100
Collection of the artist

KAREL MALICH

Untitled, 1965
Drypoint on paper
50.8 x 68.6 cm (20 x 27 inches)
Collection of Jan and Meda Mladek,
Washington, D.C.

Untitled, 1965
Drypoint on paper
50.8 x 68.6 cm (20 x 27 inches)
Collection of Jan and Meda Mladek,
Washington, D.C.

Notebook, 1967
Spiral-bound notebook with drawings
20.9 x 14.7 cm (8 1/4 x 5 5/8 inches)
Collection of the artist

Untitled, 1969–70
Drypoint on paper
52.1 x 68.6 cm (20 1/2 x 27 inches)
Collection of Jan and Meda Mladek,
Washington, D.C.

Notebook, 1970
Spiral-bound notebook with drawings
20.9 x 14.7 cm (8 1/4 x 5 5/8 inches)
Collection of the artist

Event on the Circle (Událost na elipse), 1971
Wire and thread
88 x 109 x 33 cm (34 5/8 x 42 7/8 x 13 inches)
Collection of the artist

The Black Cloud (Černy mrak), 1972
Paint, aluminum, stainless steel, and wire
110 x 130 x 130 cm (43 1/4 x 51 1/8 x 51 1/8 inches)
Collection of Jan and Meda Mladek,
Washington, D.C.

The Energy of Clouds (Energie mraků), 1973
Wire, thread, and paint
127 x 126 x 138 cm (50 x 49 5/8 x 54 3/8 inches)
Private collection, Prague

A Tree (Strom), 1976
Masonite, wire, string, and paint
63.5 x 101.6 x 25.4 cm (25 x 40 x 10 inches)
Collection of Jan and Meda Mladek,
Washington, D.C.

Notebook, 1976
Spiral-bound notebook with drawings
20.9 x 14.7 cm (8 1/4 x 5 5/8 inches)
Collection of the artist

DIMITRIJE BAŠIČEVIĆ MANGELOS

Negation of Painting (White), m5 (1951–56)
Tempera on paper
11.4 x 12 cm (4 1/2 x 4 3/4 inches)
Estate of the artist, courtesy Zdravka
Bašičević, Zagreb, and Peter Freeman, Inc.,
Brooklyn, New York

Negation of Painting (Black), m5 (1951–56)
Tempera on paper
14.9 x 12 cm (5 7/8 x 4 3/4 inches)
Estate of the artist, courtesy Zdravka
Bašičević, Zagreb, and Peter Freeman, Inc.,
Brooklyn, New York

Alphabet III, ca. 1951–63
Tempera on twenty-two pages of printed book
Each page 18.7 x 11.7 cm (7 3/8 x 4 5/8 inches)
Courtesy Peter Freeman, Inc., Brooklyn,
New York

Alfabet, 1952
Painted book: tempera on twenty-four sheets
of paper, staple-bound in paper cover
21.8 x 15.3 cm (8 5/8 x 6 inches)
Estate of the artist, courtesy Zdravka Bašičević,
Zagreb, and Peter Freeman, Inc.,
Brooklyn, New York

Pythagora 2, 1953
Painted book: tempera and oil on
twenty-seven sheets of printed coated
paper, bound in cloth-covered boards
16 x 11.5 cm (6 1/4 x 4 1/2 inches)
Estate of the artist, courtesy Zdravka Bašičević,
Zagreb, and Peter Freeman, Inc., Brooklyn,
New York

Manifesto about Thinking no. 1
(Manifest o mišljenju no 1), 1978
Acrylic on board
44.2 x 35 cm (17 3/8 x 13 3/4 inches)
Estate of the artist, courtesy Zdravka
Bašičević, Zagreb, and Peter Freeman, Inc.,
Brooklyn, New York

Energy (Energija), 1978
Acrylic and oil on globe of wood,
metal, and printed paper
51.4 x 35.6 x 33.2 cm (20 1/4 x 14 x 13 inches)
Courtesy Peter Freeman, Inc., Brooklyn,
New York

PIERO MANZONI

Line, 6m, (Linea, 6 m), 1959
Ink on paper in Plexiglas box
24 x 12 x 12 cm (9 1/2 x 4 3/4 x 4 3/4 inches)
Archivio Opera Piero Manzoni, Milan

Body of Air (Corpo d'aria), 1959–60
Wooden box with balloon, metal stand, plastic
tubing, printed instructions, and photograph
42.5 x 12.5 x 4.9 cm (16 3/4 x 4 7/8 x 1 7/8 inches)
Archivio Opera Piero Manzoni, Milan

Achrome, 1960
Cotton in squares
30 x 21 cm (12 1/4 x 8 1/4 inches)
Archivio Opera Piero Manzoni, Milan

Achrome, 1960
Pebbles and cobalt chloride on canvas
30 x 40 cm (11 3/4 x 15 3/4 inches)
Archivio Opera Piero Manzoni, Milan

Magic Base (Base magica), 1961
Wood
80 x 80 x 60 cm (31 1/2 x 31 1/2 x 23 5/8 inches)
Fondazione Mudima, Milan

Achrome, 1961–62
Paper, rope, and sealing wax
60 x 80 cm (23 5/8 x 31 1/2 inches)
Collection of Patricia Phelps de Cisneros,
Caracas, Venezuela

CILDO MEIRELES
Occupations (Ocupações), 1968–69
Pencil on graph paper
45.7 x 31.8 cm (18 x 12 1/2 inches)
Courtesy Galerie Lelong, New York

Money Tree (Árvore do dinheiro), 1969
100 folded one-cruzeiro banknotes, two rubber
bands, and traditional sculpture pedestal
7 x 7 cm (2 3/4 x 2 3/4 inches)
Collection of the artist

Southern Cross (Cruzeiro do Sul), 1969–70
Wood (pine and oak)
.9 x .9 x .9 cm (3/8 x 3/8 x 3/8 inches)
Collection of the artist

Insertions into Ideological Circuits:
Coca-Cola Project (Inserções em circuitos
ideológicos: projeto Coca-Cola), 1970
Three Coca-Cola bottles and transferred text
H. 18 cm (7 1/8 inches)
Collection of the artist

Dice (Dado), 1970
One plastic playing-die in velvet box
with engraved brass plate
8.9 x 8.9 cm (3 1/2 x 3 1/2 inches)
Edition: no. 23 of 25
Courtesy Galerie Lelong, New York

Title (Titulo), 1970
Velvet box with engraved brass plate
8.9 x 8.9 cm (3 1/2 x 3 1/2 inches)
Edition: no. 23 of 25
Courtesy Galerie Lelong, New York

Tiradenter: Totem-Monument to the
Political Prisoner (Tiradenter:
Totem-monumento ao preso político), 1970
Three black-and-white photographs
Each 25 x 30 cm (9 7/8 x 11 3/4 inches)
Collection of the artist

Insertions into Ideological Circuits: Banknote
(Inserções em circuitos ideologicos: projeto cédula),
1974–78
Ink-stamped banknotes
7.8 x 6.8 x 2 cm (3 1/8 x 2 5/8 x 3/4 inches)
Collection of the artist

Meshes of Freedom (Malhas da liberdade), 1976
Cotton mesh
Dimensions variable
Collection of the artist

Meshes of Freedom (Malhas da liberdade), 1977
Metal mesh and glass
122 x 122 x 2.5 cm (48 x 48 x 1 inches)
Collection of Patricia Phelps de Cisneros,
Caracas, Venezuela

BRUCE NAUMAN

Slow Angle Walk (Beckett Walk), 1968
Videotape, 60 mins.
Courtesy Electronic Arts Intermix, New York

Violin Tuned D.E.A.D., 1969
Videotape, 60 mins.
Courtesy Electronic Arts Intermix, New York

Pacing Upside Down, 1969
Videotape, 56 mins.
Courtesy Electronic Arts Intermix, New York

Studies for Holograms, 1970
Portfolio of five screenprints
66 x 66 cm (26 x 26 inches)
Courtesy Sonnabend Gallery, New York

HÉLIO OITICICA

Box Bolide 8, 1964 (reconstruction)
Oil on wood, yellow plastic, and nylon net
Approximately 101 x 51 x 40 cm
(40 x 20 x 16 inches)
Projeto Hélio Oiticica, Rio de Janeiro

Parangole P4 Cape 1, 1964 (reconstruction)
Oil and acrylic on textile, plastic,
and nylon net
Approximately 142 x 61 x 10 cm
(56 x 24 x 4 inches)
Projeto Hélio Oiticica, Rio de Janeiro

Parangolé P16 Cape 12: Of Adversity We Live,
1964 (reconstruction)
Cotton with text, plastic bag with
various objects, and nylon net
Approximately 142 x 61 x 10 cm
(55 7/8 x 24 x 3 7/8 inches)
Projeto Hélio Oiticica, Rio de Janeiro

LAWRENCE WEINER

What Is Set upon the Table Sits upon the Table,
1960–62 (reconstruction)
Limestone and wooden table
Stone: 133 x 91 x 76 cm (53.2 x 36.4 x 30.4 inches); table: 108.6 x 77.5 x 62.2 cm
(42 3/4 x 30 1/2 x 24 1/2 inches)
Collection of the Stedelijk Museum, Amsterdam

*TWO MINUTES OF SPRAY PAINT DIRECTLY UPON THE
FLOOR FROM A STANDARD AEROSOL SPRAY CAN*,
1967 (reconstruction)
Language + the materials referred to + certificate
Certificate: ink on paper, 27.5 x 21.3 cm (11 x
8 1/2 inches)
The LeWitt Collection, Chester, Connecticut

STATEMENTS, 1968
Book, published by the Louis Kellner Foundation
and Seth Siegelaub, New York
18.4 x 10.2 x .3 cm (7 1/4 x 4 x 1/8 inches)
Edition unknown
Collection of Alice Weiner, New York

A Square Removal from a Rug in Use, 1969
(reconstruction)
Language + the materials referred to
Dimensions variable
Collection of the Museum Moderner Kunst
Stiftung Ludwig, Vienna

*FIRECRACKER RESIDUE OF EXPLOSIONS AT EACH
CORNER OF THE EXHIBITION AREA*, 1969
Language + the materials referred to
Dimensions variable
The Siegelaub Collection & Archives at the
Stichting Egress Foundation, Amsterdam

*FLOATABLE OBJECTS THROWN INTO INLAND WATER-
WAYS ONE EACH MONTH FOR SEVEN YEARS*, 1969
Language + the materials referred to
Dimensions variable
Public freehold, courtesy of the artist

ARTISTS BIOGRAPHIES

JOSEPH BEUYS

Joseph Beuys was born in 1921 in Kleve, Germany. Solo exhibitions of his work have appeared at such institutions as the Solomon R. Guggenheim Museum, New York (1979–80); Museum Fridericianum, Kassel, Germany (1993); the Andy Warhol Museum, Pittsburgh (1995); and the Walker Art Center, Minneapolis (1997). Among the numerous group exhibitions that have included his work are *Fifty Years of Collecting: An Anniversary Selection, Sculpture of the Modern Era* at the Solomon R. Guggenheim Museum (1988); *Works on Paper* at the Irish Museum of Modern Art, Dublin (1994); and *Out of Actions: Between Performance and the Object, 1949–1979* at The Museum of Contemporary Art, Los Angeles (1998). Beuys died in 1986 in Düsseldorf.

MARCEL BROODTHAERS

Marcel Broodthaers was born in Brussels in 1924. Since 1964, his solo exhibitions have appeared internationally at venues such as Galerie Saint-Laurent, Brussels (1964); Galerie Michael Werner, Cologne (1969, 1970, 1973, 1974, 1976, 1980, 1983, 1986, 1987); the Tate Gallery, London (1980); the Museum of Contemporary Art, Los Angeles (1989–90); and the Marian Goodman Gallery, New York (1978, 1979, 1982, 1984, 1986, 1995, 1997). His work has also been included in group exhibitions such as *Lauréats du Prix Sculpture Jeune Belge*, Palais des Beaux-Arts, Brussels (1964); *Information*, the Museum of Modern Art, New York (1970); the *Venice Biennale* (1976); *Forty Years of Modern Art 1945–85*, the Tate Gallery, London (1986); and *Documenta 10* in Kassel, Germany (1997). Broodthaers died in Cologne in 1976.

LYGIA CLARK

Lygia Clark was born in 1920 in Belo Horizonte, Brazil. She was a member of Grupo Frente from 1954 to 1956. In the 1970s, she became interested in the therapeutic values of art in which the viewer becomes physically involved, and from 1978 on she dedicated herself solely to practicing psychoanalysis. Among Clark's solo shows were two retrospectives at the Paço Imperial do Rio de Janeiro (1986) and the Museu de Arte Contemporãnea da Universidade de São Paulo (1987). Her work was presented in numerous group exhibitions at venues such as the Ministério da Educação e Cultura, Rio de Janeiro (1952); the *Bienal de São Paulo* (1953, 1955, 1957, 1959, 1961, 1963, 1967); the *Venice Biennale* (1960, 1962, 1968); and Signals Gallery, London (1962). More recently, her work was shown in the group exhibition *Out of Actions: Between Performance and the Object, 1949–1979* at the Museum of Contemporary Art, Los Angeles (1998). Clark died in 1988 in Rio de Janeiro.

HANNE DARBOVEN

Hanne Darboven was born in 1941 in Munich and attended the Hochschule für Bildende Kunst in Hamburg. In 1967, she had her first solo exhibition, entitled *Konstruktionen-Zeichnungen*, at the Konrad Fischer Galerie, Düsseldorf. Since then, she has had solo exhibitions at Leo Castelli, New York (1973, 1978, 1981, 1984, 1987, 1990, 1993, 1995); Galerie Paul Maenz, Cologne (1981, 1987); the Goethe-Institut, London (1994); Sperone Westwater, New York (1998); and again at the Konrad Fischer Galerie (2000). Among the numerous

group exhibitions in which her work has been presented are *Information* at the Museum of Modern Art, New York (1970); *Documenta 7* in Kassel, West Germany (1982); *Out of Sight, Out of Mind* at the Lisson Gallery, London (1993); *Reconsidering the Object of Art, 1965–1975* at the Museum of Contemporary Art, Los Angeles (1995–96); and the *Carnegie International 1999/2000* at the Carnegie Museum of Art, Pittsburgh. Darboven currently resides in Hamburg.

BETTY GOODWIN

Canadian artist Betty Goodwin was born in Montreal in 1923. Goodwin's work has been presented in numerous solo exhibitions at such locations as Galerie B, Montreal (1973, 1974, 1976) and Galerie René Blouin, Montreal (1986, 1989, 1990, 1993, 1995, 1996, 1998, 1999); Jack Shainman Gallery, New York, will present her work in 2000. Goodwin has also participated in various group exhibitions, including *Print Exhibition* at the Musée des Beaux-Arts de Montréal (1950); *Ninth International Biennial Exhibition of Prints* in Tokyo (1975); and *Redefining the Still Life* at the Leonard and Bina Ellen Art Gallery, Concordia University, Montreal (1999). Goodwin lives and works in Montreal.

VICTOR GRIPPO

Victor Grippo was born in Junín, Argentina, in 1936. Since 1953, he has had solo exhibitions at many venues in Argentina, including Galería Colegio Nacional, Junín (1953); Galería Arte múltiple, Buenos Aires (1976, 1980); and Galería Alvaro Castagnino, Buenos Aires

(1989); and internationally at Fawbush Projects, New York (1991) and the Palais des Beaux-Arts, Brussels (1995). Among the many group exhibitions that have shown his work are the *Paris Biennale*, held at the Musée National d'Art Moderne, Centre Georges Pompidou, Paris (1969); the *Bienal de São Paulo* (1977); *Art from Argentina* at the Museum of Modern Art, Oxford (1994); *Out of Actions: Between Performance and the Object, 1949–1979* at the Museum of Contemporary Art, Los Angeles (1998); and *Global Conceptualism: Points of Origin, 1950s–1980s* at the Queens Museum of Art, Flushing, New York (1999). Grippo lives in Buenos Aires.

EVA HESSE

Eva Hesse was born in 1936 in Hamburg and studied in the United States at Cooper Union, New York, and Yale University, New Haven, Connecticut. Her work was first exhibited at the John Heller Gallery in New York in an exhibition entitled *Drawings: Three Young Americans*, and her first solo exhibition was held in 1963 at the Allan Stone Gallery, New York. Her work has been shown many times over the years at the Robert Miller Gallery, New York, in both solo and group shows. Retrospectives have been shown at the Solomon R. Guggenheim Museum, New York (1972–73), and Yale University Art Gallery (1992). A major retrospective, organized by the San Francisco Museum of Modern Art and the Museum Wiesbaden, Germany, is scheduled for 2001. Hesse's work has been included in many group exhibitions, such as the *Twenty-first International Watercolor Biennial* at

the Brooklyn Museum, New York (1961); *The Permanent Collection: Women Artists* at the Whitney Museum of American Art, New York (1970–71); *Transformations in Sculpture: Four Decades of American and European Art* at the Solomon R. Guggenheim Museum, New York (1985–86); and the *Bienal de São Paulo* (1996). Hesse died in New York in 1970.

ILYA KABAKOV

Ilya Kabakov was born in Dnipropetrovsk, Soviet Union (now Ukraine), in 1933. Since 1985, he has had solo exhibitions at the Kunsthalle Bern, Switzerland (1985); the Hirshhorn Museum and Sculpture Garden, Smithsonian Institution, Washington, D.C. (1990); and the Tate Gallery, London (2000). Since 1965, his work has also been presented in numerous group exhibitions, such as *Contemporary Alternatives/2* at Castello Spagnolo, L'Aquila, Italy (1965); the *Venice Biennale* (1977, 1988, 1993, 1997); *Rhetorical Image* at the New Museum of Contemporary Art, New York (1990); the *1997 Biennial Exhibition* at the Whitney Museum of American Art, New York (1997); and *Around 1984: A Look at the Eighties* at P.S.1 Contemporary Art Center, Long Island City, New York (2000). In 1993, he was awarded the Max Beckmann Prize and the Joseph Beuys Prize; in 1997, he won the Art Critics Association Award. He recently completed a work for the Public Art Fund, New York, entitled *Palace of Projects*. Kabakov currently resides in New York and Paris.

ON KAWARA

On Kawara was born in 1933 in Kariya, Aichi Prefecture, Japan, and moved to New York in 1965. His first solo exhibition outside the U.S. took place in 1971 at the Konrad Fischer Galerie, Düsseldorf, which later presented his work in various shows (1980, 1981, 1988, 1997). Other venues for solo exhibitions include the Musée National d'Art Moderne, Centre Georges Pompidou, Paris (1977); Lisson Gallery, London (1985); the San Francisco Museum of Modern Art, (1993); and Sperone Westwater Fischer (later Sperone Westwater), New York (1976, 1982, 1988, 1990, 1993). Kawara's group exhibitions include *Seventy-third American Exhibition* at the Art Institute of Chicago (1979); *Documenta 7* in Kassel, West Germany (1982); *Magiciens de la terre* at the Musée National d'Art Moderne, Centre Georges Pompidou, Paris (1989); *Rhetorical Image* at the New Museum of Contemporary Art, New York (1990); and *On the Edge: Contemporary Art from the Werner and Elaine Dannheisser Collection* at the Museum of Modern Art, New York (1997–98). Kawara divides his time between New York and Tokyo.

JIŘÍ KOLÁŘ

Jiří Kolář was born in 1914 in Protivín, Bohemia (now Czech Republic). In 1942, he was a founding member of Group 42. In 1968, his work received critical acclaim at *Documenta 4* in Kassel, West Germany, and in 1974 the Solomon R. Guggenheim Museum, New York, presented a retrospective of his work. Other venues at which his work has been shown include Divadlo E. F. Buriana, Prague (1937); the *Venice Biennale* (1968);

the Institut für Moderne Kunst, Nuremberg, Germany (1968, 1971); and the National Gallery in Prague (1993, 2000). He has also participated in the group exhibitions *Between Poetry and Painting* at the Institute of Contemporary Art (ICA), London (1965); *Au temps de l'espace* at the Musée National d'Art Moderne, Centre Georges Pompidou, Paris (1983); and *Rhetorical Image* at the New Museum of Contemporary Art, New York (1990). Kolář moved to Paris in 1979 and returned to Prague in 1999.

EDWARD KRASIŃSKI

Edward Krasiński was born in Luck, Poland, in 1925. He has had numerous solo exhibitions at such venues as Galeria Krzystofory, Kraków (1965); Galeria Foksal, Warsaw (1966, 1968, 1984–1987, 1989, 1990, 1994, 1995, 1997); Galerie 28, Paris (1975); Galeria Pawilon, Kraków (1976, 1978); Galerie Donguy, Paris (1988, 1992); Kunsthalle Basel, Switzerland (1996); and Galeria Arsenal, Bialystok (1998). His work has also been shown in many group exhibitions including *Konfrontacje, 1956–1962* at Galeria Krzywe Kolo, Warsaw (1962); *Guggenheim International Exhibition 1967: Sculpture from Twenty Nations* at the Solomon R. Guggenheim Museum, New York (1967); the *Venice Biennale* (1976); *Dialog* at the Moderna Museet, Stockholm (1985); *L'Autre Moitié de l'Europe* at Galerie Nationale du Jeu de Paume, Paris (2000); and *Manifesta*, Ljubljana (2000). Krasiński currently resides in Warsaw.

JOHN LATHAM

John Latham was born in Rhodesia (now Zimbabwe) in 1921. He was a cofounder of the Artist Placement Group, later renamed Organization and Imagination (O + I). His first solo exhibition was in 1948 at Kingly Gallery, London, and his first American solo exhibition was in 1963 at Alan Gallery, New York. Group exhibitions that presented his work include *The Art of Assemblage* at the Museum of Modern Art, New York (1961); *Painting and Sculpture of a Decade* at the Tate Gallery, London (1964), *Documenta 6* in Kassel, West Germany (1977); and *British Art in the 20th Century* at the Royal Academy of Arts, London (1987). His work has also been shown at the Galleria dell'Ariete, Milan (1959); the Galerie Internationale d'Art Moderne, Paris (1962); the Stedelijk van Abbemuseum, Eindhoven, The Netherlands (1983); and the Staatsgalerie Stuttgart (1991). Latham lives and works primarily in London.

SOL LEWITT

Sol LeWitt was born in Hartford, Connecticut, in 1928. LeWitt has had many solo and group exhibitions, with his first retrospective presented in 1970 at the Haags Gemeentemuseum, The Hague, The Netherlands; and another in 1978 at the Museum of Modern Art, New York. In 2000, the San Francisco Museum of Modern Art organized the first LeWitt retrospective in twenty years. Group exhibitions that presented his work include *Documenta 4* in Kassel, West Germany (1968); *Drawing Now* at the Tel Aviv Museum of Art, Israel (1977); *17th Biennial of Sculpture* in Antwerp, Belgium (1982); *L'Art Conceptuel, Une Perspective* at the Musée d'Art Moderne de

la Ville de Paris, France (1989–1990); and *The American Century: Art & Culture,* Part 2: *1950–2000* at the Whitney Museum of American Art, New York (1999). LeWitt resides in New York and Chester, Connecticut.

ANA MARIA MAIOLINO

Brazilian artist Ana Maria Maiolino was born in Scalea, Italy, in 1942. Solo exhibitions of her work have been on view at Galería G, Caracas, Venezuela (1964); Arte Global Gallery, São Paulo (1974); Escritório Brasiliera de Artes, São Paulo (1981); the Joel Edelstein Contemporary Art Gallery, Rio de Janeiro (1997); and other venues. In 1960, she participated in the twenty-first National Salon of Venezuelan Art in Caracas. Subsequent group exhibitions include *Brazilian Drawing 1974* at the Museu de Arte Moderna, Rio de Janeiro (1975); the first *Havana Bienal* (1984); the *Bienal de São Paulo* (1991); *America, Bride of the Sun: 500 Years of Latin America and the Low Countries* at the Koninklijk Museum voor Schone Kunsten, Antwerp, Belgium (1992); and *Realigning Vision: Alternative Currents in South American Drawings* at the Miami Art Museum, Florida (1999). Maiolino currently lives and works in Rio de Janeiro.

KAREL MALICH

Karel Malich was born in 1924 in Holice, Czechoslovakia. Beginning with his first solo exhibition at Galerie Hollar, Prague (1964), his work has been presented at several Czech galleries, such as Dům umění města Brna (1989), Gallery of the City of Prague (1990), and Galerie MXM (1992 , 1996, 1998). Solo exhibitions of his work have also been held at Galerie Prakesch, Vienna (1993), Museum

Fridericianum, Kassel (1995), the *Venice Biennale,* the Czech Pavilion (1995), and Kunsthalle Krems (1996). Selected group exhibitions include *The Group Krizovatka* at V. Spála Galerie, Prague (1963); *Sculptures from Twenty Nations* at the Solomon R. Guggenheim Museum, New York (1967); *Konstruktivisme i Louisianas Samling,* Louisiana Museum of Modern Art, Humlebaek, Denmark (1986); *Magiciens de la terre,* at the Musée National d'Art Moderne, Centre Georges Pompidou, Paris (1989); *Reduktivismus, Abstraktion in Polen, Tschgechoslowakei, Ungarn 1950–1980*, Museum Moderner Kunst Stiftung Ludwig, Vienna (1992); *Europa, Europa: Das Jahrhundert der Avantgarde in Mittel- und Osteuropa*, Kunst- und Ausstellungshalle der Bundesrepublik Deutschland, Bonn (1994); *Der Riss im Raum: Positionen der Kunst seit 1945 in Deutschland, Polen, der Slowakei und Tschechien,* Martin-Gropius-Bau, Berlin (1994), and *L'Autre Moitié de l'Europe* at the Galerie Nationale du Jeu de Paume, Paris (2000). Malich currently resides in Prague.

DIMITRIJE BAŠIČEVIĆ MANGELOS

Dimitrije Bašičević Mangelos was born in 1921 in Šid, Yugoslavia. He was a founding member of an intellectual association of artists, called Gorgona (1959–66). In 1998, the first U.S. exhibition of his work opened in New York at the A/D Gallery, and was later installed at the Anthony d'Offay Gallery in London. In 1990, a retrospective of his work was held at the Museum of Contemporary Art in Zagreb. He has had solo shows at venues such as Tribinia Mladih, Novi Sad (1972); Galerija Dubrava, Zagreb (1979); Galerija Sebastian, Belgrade

(1986); Galerie Rainer Borgemeister, Berlin (1997); and Miami-Dade Community College, Miami (1999). Group exhibitions that presented his work include *Permanent Art* at Galerija 212 in Belgrade (1968); *Innovations in Croation Art in the '70s* at Galerija suvremene umjetnosti in Zagreb (1982); *The Horse Who Sings: Radical Art from Croatia* at the Museum of Contemporary Art in Sydney (1993); and *Das Fünfte Element — Geld oder Kunst* at the Städtische Kunsthalle, Düsseldorf (2000). He died in 1987 in Zagreb, Yugoslavia (now Croatia).

PIERO MANZONI

Piero Manzoni was born in Soncino, Italy, in 1933. In 1957, he had his first solo exhibition at the Teatro delle Maschere in Milan; and in 1972, his first U.S. exhibition opened at the Contemporary Arts Museum, Houston. Retrospectives of his work were held at the Tate Gallery, London (1974) and the Musée d'Art Moderne de la Ville de Paris (1991). Among the other musuems and galleries that have shown his work are the Stedelijk van Abbemuseum, Eindhoven, The Netherlands (1969); the Kunstmuseum, Basel, Switzerland (1973); the Städtische Kunsthalle, Düsseldorf (1976); and Hirschl & Adler, New York (1990). His work was also included in the exhibition *Italian Art in the Twentieth Century* at the Royal Academy of Arts, London (1989) and in *a/drift: Scenes from the Penetrable Culture* at the Center for Curatorial Studies Museum at Bard College, New York (1996–97). He died in 1963 in Milan.

CILDO MEIRELES

Cildo Meireles was born in Rio de Janeiro in 1948. Solo exhibitions of his work have been shown many times at Galeria Luisa Strina, São Paulo; Galeria Saramenha, Rio de Janeiro; and the Museu de Arte Moderna, Rio de Janeiro, which has also included his work in numerous group exhibitions. The Museum of Modern Art, New York, held a solo exhibition of Meireles's work in 1990; and a retrospective was presented at the New Museum of Contemporary Art, New York, in 1999. Among the many group exhibitions in which he has participated are *Information* at the Museum of Modern Art, New York (1970); the *Venice Biennale* (1976); *Les Magiciens de la Terre* at the Musée National d'Art Moderne, Centre Georges Pompidou, Paris (1989); *20 Anos de Arte Brasileira* at the Museu de Arte de São Paulo (1994). Meireles currently resides in Rio de Janeiro.

BRUCE NAUMAN

Bruce Nauman was born in Fort Wayne, Indiana, in 1941. Since the 1960s, he has had many solo exhibitions in both the United States and Europe, presented by institutions such as the Nicholas Wilder Gallery, Los Angels (1966); the Los Angeles County Museum of Art (1973); the Staatliche Kunsthalle Baden-Baden, Germany (1981); the Whitechapel Art Gallery, London (1987); the Walker Art Center, Minneapolis; the Hirshhorn Museum and Sculpture Garden, Smithsonian Institution, Washington, D.C. (1994–95); and the Kunsthalle, Vienna (2000). Nauman has also participated in many group exhibitions,

including *American Sculpture of the Sixties* at the Los Angeles County Museum of Art (1967); *Documenta 5* in Kassel, West Germany (1972); the *Venice Biennale* (1980); and *Afterimage: Drawing through Process* at the Museum of Contemporary Art, Los Angeles (1999). Among the numerous honors and awards he has received are the Artist Fellowship Award from the National Endowment for the Arts (1968); the Max Beckmann Prize (1990); and the Leone d'oro (Golden Lion) at the *Venice Biennale* (1999). Nauman currently resides in Galisteo, New Mexico.

HÉLIO OITICICA

Hélio Oiticica was born in 1937 in Rio de Janeiro. A solo exhibition devoted to Oiticica's work was presented at the Whitechapel Art Gallery, London, in 1969. His work has been shown on several occasions in group exhibitions at the Museu de Arte Moderna, Rio de Janeiro, beginning with Grupo Frente's second exhibition (1955) and later in other exhibitions (1956, 1961, 1966, 1967, 1970, 1972). He also participated in the Tokyo and Paris biennials (1967), *Information* at the Museum of Modern Art, New York (1970); *Out of Actions: Between Performance and the Object*, 1949–1979 at the Museum of Contemporary Art, Los Angeles (1998); and *Global Conceptualism: Points of Origin, 1950s–1980s* at the Queens Museum of Art, Flushing, New York (1999). From 1971 to 1978, he lived in New York, where he experimented with film. Oiticica returned to Rio de Janeiro in 1978, where he died in 1980.

LAWRENCE WEINER

Lawrence Weiner was born in 1942 in Bronx, New York, where he began his career as a sculptor. His first solo exhibition was held in 1960 in Mill Valley, California, with subsequent shows at, among others, the Konrad Fischer Galerie, Düsseldorf (1969, 1975, 1977, 1981, 1985, 1989); Leo Castelli, New York (1971, 1972, 1973, 1974, 1976, 1981, 1991, 1995); Art and Project, Amsterdam, The Netherlands (1969, 1971, 1972, 1973); and Wide White Space, Antwerp, Belgium (1969, 1972, 1973). Group exhibitions that he participated in include *Group Show* at Seth Siegelaub, New York (1964); *Information* at the Museum of Modern Art, New York (1970); *Seventy-second American Exhibition* at the Art Institute of Chicago (1976); *Documenta 7* in Kassel, West Germany (1982); *Comic Iconoclasm* at the Institute of Contemporary Art, London (1987); *La Biennale d'art contemporain*, Lyon, France (1993); and *Views from Abroad: European Perspectives on American Art* at the Whitney Museum of American Art, New York (1997). Weiner lives in New York.

Alberro, Alexander and Blake Stimson, eds. *Conceptual Art: A Critical Anthology.* Cambridge, Mass. and London: MIT Press, 1999.

Aspekte/Positionen: 50 Jahre Kunst aus Mitteleuropa 1949–1999. Exh. cat. Vienna: Museum Moderner Kunst Stiftung Ludwig, 1999.

Badovinac, Zdenka. *Body and the East: From the 1960s to the Present.* Exh. cat. Ljubljana, Slovenia: Museum of Modern Art, 1998.

Belluzzo, Ana Maria de Moraes, ed. *Modernidade: Vanguardas Artísticas na América Latina.* São Paulo: Memorial, Editora UNESP, 1990.

Bois, Yve-Alain and Rosalind E. Krauss. *Formless: A User's Guide.* New York: Zone Books, 1997.

Bourriaud, Nicolas. *Esthétique Relationelle.* Dijon, France: Presses du réel, 1998.

Brett, Guy. *Transcontinental: An Investigation of Reality: Nine Latin American Artists.* London and New York: Verso, 1990.

Bryson, Scott et al., eds. *Beyond Recognition: Representation, Power, and Culture.* Berkeley: University of California Press, 1992.

Camnitzer, Luis, Jane Farver, and Rachel Weiss. *Global Conceptualism: Points of Origin, 1950s–1980s.* Exh. cat. Flushing, New York: Queens Museum of Art, 1999.

Carvajal, Rina and Alma Ruiz. *The Experimental Exercise of Freedom.* Exh. cat. Los Angeles: Museum of Contemporary Art, 2000.

Cooke, Lynne and Karen Kelly, eds. *Robert Lehman Lectures on Contemporary Art.* Vol. II. New York: Dia Center for the Arts, forthcoming, 2001.

Crimp, Douglas. *On the Museum's Ruins.* Cambridge, Mass. and London: MIT Press, 1993

Crow, Thomas E. *The Rise of the Sixties: America and European Art in the Era of Dissent.* New York: Harry N. Abrams, Inc. 1996.

Deleuze, Gilles. *Bergsonism.* Trans. Hugh Tomlinson and Barbara Habberjam. New York: Zone Books, 1991.

——, *Difference and Repetition.* Trans. Paul Patton. New York: Columbia University Press, 1994.

Fer, Briony. *On Abstract Art.* New Haven and London: Yale University Press, 1997.

Foster, Hal. *The Return of the Real: The Avant-garde At the End of the Century.* Cambridge, Mass.: MIT Press, 1996.

Godfrey, Tony. *Conceptual Art.* London: Phaidon, 1998.

Goldstein, Ann and Anne Rorimer. *Reconsidering the Object of Art: 1965–75.* Exh. cat. Los Angeles: Museum of Contemporary Art; and Cambridge, Mass.: MIT Press, 1997.

Groys, Boris. *Gesamtkunstwerk Stalin: Die gespaltene Kultur in der Sowjetunion.* Munich and Vienna: C. Hanser Verlag, 1988; American edition: *The Total Art of Stalinism.* Trans. C. Rougle. Princeton, NJ, 1992.

———. *"A Voyage on the North Sea": Art in the Age of the Post-Medium Condition.* London: Thames and Hudson, 1999.

LeWitt, Sol. "Paragraphs on Conceptual Art." *Artforum* 5 (June 1967), Reprinted in *Sol LeWitt: Critical Texts,* ed. Adachiara Zevi. Rome: Inonia, 1995.

Lippard, Lucy. *Six Years: The Dematerialization of the Art Object from 1966–1972.* New York: Praeger, 1973; reissued Berkeley and Los Angeles, Calif. and London: University of California Press, 1997.

Morgan, Robert C. *Art into Ideas: Essays on Conceptual Art.* Cambridge, England and New York: Cambridge University Press, 1996.

Mosquera, Gerardo, ed. Beyond the Fantastic: Contemporary Art Criticism from Latin America. London: Institute of International Visual Arts; and Cambridge, Mass.: MIT Press, 1995.

Newman, Michael and Jon Bird, eds. *Rewriting Conceptual Art.* London: Reaktion Books, 1999.

Rasmussen, Waldo, Fatima Bercht, and Elizabeth Ferrer. *Latin American Artists of the Twentieth Century*. Exh. cat. New York: Museum of Modern Art, 1993.

Reduktivismus: Abstraktion in Polen, Tschechoslowakei, Ungarn 1950–1980. Exh. cat. Vienna: Museum Moderner Kunst Stiftung Ludwig, 1992.

Der Riss im Raum: Positionen der Kunst seit 1945 in Deutschland, Polen, der Slowakei und Tschechien. Exh. cat. Berlin: Martin-Gropius-Bau, 1994.

Roberts, John, eds. *The Impossible Document: Photography and Conceptual Art, 1966–76.* London: Camerawork, 1997.

Schimmel, Paul. *Out of Actions: Between Performance and the Object, 1949–1979.* Exh. cat. Los Angeles: Museum of Contemporary Art; and London: Thames and Hudson, 1998.

Stanislawski, Ryszard and Christoph Brockhaus. *Europa, Europa: Das Jahrhundert der Avantgarde in Mittel-und Osteuropa.* Exh. cat. Bonn: Kunst- und Ausstellungshalle der Bundesrepublik Deutschland, 1994.

Traba, Marta. *Art of Latin America, 1900-80.* Washington, D.C.: Inter-American Development Bank, 1994.

XXIV Bienal de São Paulo. São Paulo: Representações Nacionais, Fundaçao Bienal de São Paulo, 1998.

Vandenbroeck, Dr. Paul and M. Catherine de Zegher. *America, Bride of the Sun: 500 Years of Latin America and the Low Countries.* Exh. cat. Antwerp, Belgium: Royal Museum of Fine Arts; and Brussels: Imschoot Books, 1992.

Williams, Richard J. *After Modern Sculpture: Art in the United States and Europe, 1965–70.* Manchester: Manchester University Press, 2000.

LENDERS TO THE EXHIBITION

Archivio Opera Piero Manzoni, Milan

The Bailey Collection, Toronto

Zdravka Bašičević, Zagreb

Chase Manhattan Bank

Estate of Lygia Clark, courtesy Museu de Arte Moderna, Rio de Janeiro

Paula Cooper

George H. Coppers

Patricia Phelps de Cisneros

Electronic Arts Intermix, New York

Ronald Feldman Fine Arts, Inc.. New York

Fondazione Mudima, Milan

Peter Freeman, Inc., Brooklyn, New York

The Carol and Arthur Goldberg Collection, New York

Betty Goodwin, courtesy Galerie René Blouin, Montreal

Jorge and Marion Helft, Buenos Aires

Estate of Eva Hesse, courtesy Galerie Hauser & Wirth, Zürich

Ilya and Emilia Kabakov

On Kawara and Hiroko Kawahara

Jiří Kolář

Paulina Krasiński, courtesy Galeria Foksal Foundation, Warsaw

John Latham

Raymond Learsy, New York

Galerie Lelong, New York

Mirella and Daniel Levinas, Bethesda, Maryland

The LeWitt Collection, Chester, Connecticut

Lisson Gallery, London

Nicholas Logsdail

Anna Maria Maiolino

Karel Malich

Cildo Meireles

Collection of Jan and Meda Mladek, Washington, D.C.

Museum Moderner Kunst Stiftung Ludwig, Vienna

Neuberger Berman, New York

New School University, New York

Projeto Hélio Oiticica, Rio de Janeiro

Edition Schellmann, Munich-New York

The Siegelaub Collection & Archives at the Stichting Egress Foundation, Amsterdam

Sonnabend Gallery, New York

Stedelijk Museum, Amsterdam

Barbara Steveni

Museum Sztuki, Lodz, Poland

University of California, Berkeley Art Museum, Berkeley

Weatherspoon Art Gallery, The University of North Carolina at Greensboro

Alice Weiner

Lawrence Weiner

Catherine de Zegher

Galerie Zlatá Husa, Prague

Anonymous lenders

INDEX

Note: Page numbers in italics refer to illustrations.

PHOTO CREDITS